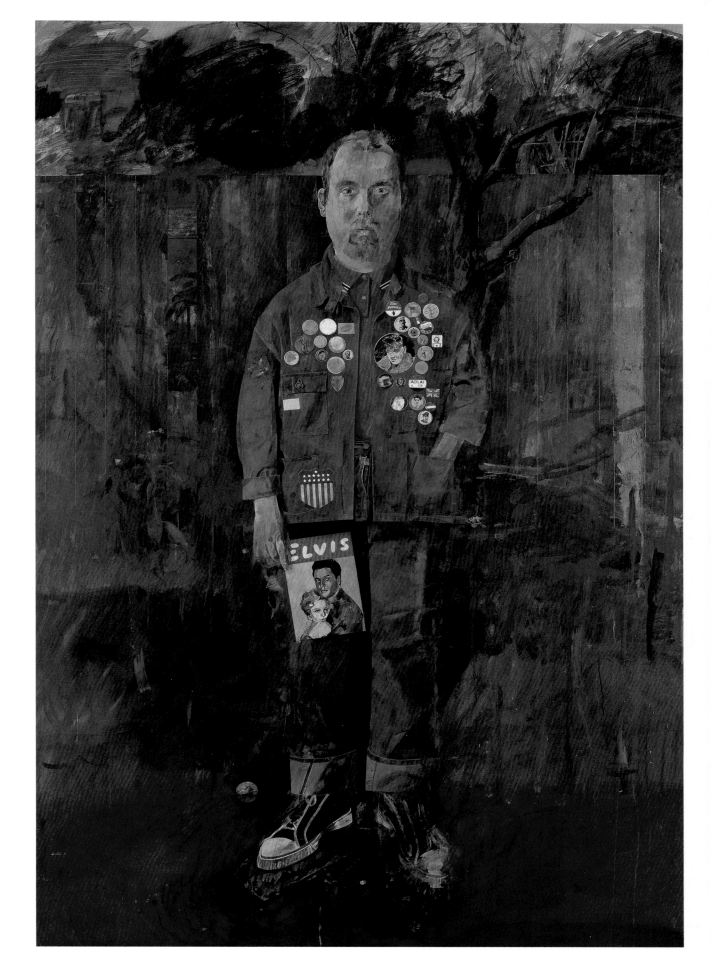

MODERN ARTISTS

First published 2003 by order of the Tate Trustees
by Tate Publishing, a division of Tate Enterprises Ltd,
Millbank, London SW1P4RG
www.tate.org.uk
© Tate 2003

The moral rights of the author have been asserted.
British Library Cataloguing in Publication Data
A catalogue record for this book is available from the
British Library
ISBN 1 85437 419 2 (pbk)
Distributed in the United States and Canada by
Harry N. Abrams, Inc., New York
Library of Congress Cataloging in Publication Data
Library of Congress Control Number: 2003103442
Designed by UNA (London) Designers
Printed in Singapore

Front cover (detail) and previous page:
SELF-PORTRAIT WITH BADGES 1961 (fig.99)

Overleaf: THE TOY SHOP 1962 (detail, fig.29)
Measurements of artworks are given in centimetres, height
before width, followed by inches in brackets

Author's acknowledgements

I am indebted to Peter Blake for his generosity and time
over the past few years and for being such a fascinating
person to write about. I would also like to thank the Blake
family – especially Chrissy Wilson – and Waddington
Galleries, Tate Liverpool, Celia Clear, Mary Richards,
Katherine Rose, Daniel Scott, Vicky Charnock and
Leo Fitzmaurice for their input and assistance. I am very
grateful to Lewis Biggs and Victoria Pomery for their
ongoing support and encouragement. With lots of love
to Mum, Dad, Jez and Kate – and with extra special thanks
to Mum and Martin for their immense patience and help.

Artist's acknowledgements

My thanks to Natalie Rudd, both for writing this book
and her work with me on my exhibition *About Collage* at
Tate Liverpool. Love and thank you for everything to my
wife Chrissy, and my daughters Liberty, Daisy and Rose,
my mother, brother, sister, family and friends. Thank you
too to Leslie Waddington and everyone at Waddington
Galleries. Finally, thank you to all those who I worked with
at Tate Liverpool and Tate Publishing on *About Collage*
and this book.

Natalie Rudd

Tate Publishing

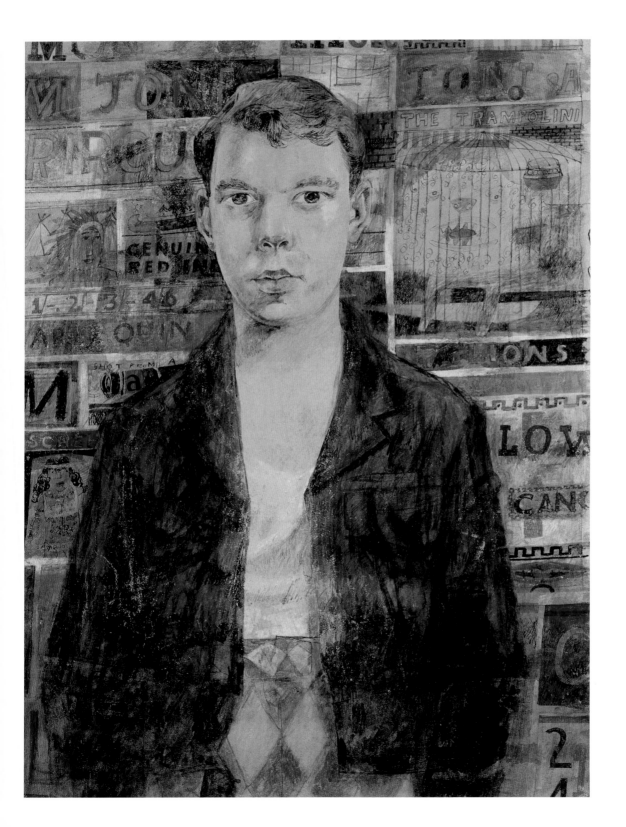

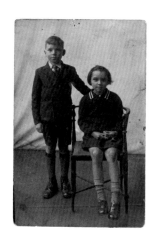

Peter and his sister Shirley, 1942 [2]

1

ROOTS

I am a tree, so to speak. The trunk is straight and fairly traditional. Where my art has left to go on different excursions there are branches like Pop Art, wood engraving, and Ruralism. They all may look unalike but they come off the same stem. What I am working at now is in direct line with what preoccupied me years ago; the same fantasies.[1]

The diversity of Peter Blake's work is extraordinary. Many people know his famous design for the cover of The Beatles' *Sgt Pepper's Lonely Hearts Club Band* album, but less recognised is the range of paintings, collages, sculptures, prints, drawings, collections and illustrations that he has pursued with a passion for over half a century. Blake has always sustained the 'branches' of his art by extracting nourishment from his immediate environment. He finds more inspiration in going out to pursue a vast range of interests and in enjoying the company of friends than through any injection of art theory. Yet, despite his love of life's variety, he remains steadfastly rooted, determinedly unique. To meet him is to encounter a genuinely eccentric character – generous and warm, slightly shy, unconventional, obsessive, childlike almost, in his unashamed interest in a vast array of unusual and often unfashionable subjects. His work shares this honest simplicity. It focuses on love and magic, beauty and tradition in ways that have often captured the public imagination.

Blake's position within the lineage of British art history is not as secure as his celebrity implies. Many critics have considered his work too whimsical, too jokey; too far removed from the serious issues of the day to warrant prolonged consideration. But the very qualities that render his art so out of touch are exactly those that make it so intriguing. Blake is a genuine outsider. There is no separation between his art and

his life. To investigate his work sympathetically is not to explore the branches of his practice in isolation, but to assess his life as a whole. In doing so, one uncovers a remarkable tale and a truly inimitable artist.

Roots are important to Blake. Although locations are seldom specified, his work exudes an overall feeling of Englishness, reflecting the artist's affection for his native soil. Also in evidence is a certain feeling of nostalgia. For Blake, the past is an evergreen presence within his life and the world at large, to be preserved and cherished in his work. Unlike many artists who aim to forget their immature experiences in search of an established future, he has kept the link between childhood and adulthood very much alive. Many of the motivations behind his mature work emerged during his youth.

Peter Thomas Blake was born on 25 June 1932 in Dartford, Kent. He was the eldest of three children: his sister, Shirley, arrived in 1935, Terry, his brother, in 1939. Their mother, Betty, was a nurse, and their father, Kenneth, an electrician. Although initially unremarkable, Blake's lower-middle class upbringing was supportive and loving and some of his earliest memories centre on his parents' desire to amuse their children. His mother was an ardent fan of the cinema and took him to the pictures practically every day from the age of three or four, providing him with a 'great education in films'. She also loved shopping and would sometimes return from the weekly shopping trip with boxed gifts containing small lead toys, which Blake would probably have collected had world events not intervened.

The outbreak of the Second World War changed everything. Blake and his sister were separated from their parents and new-born brother and evacuated to Helions Bumpstead, a village in rural Essex. They were greeted by a Mrs Loft, a family acquaintance,

ABC MINORS 1955 [3]
Oil on hardboard
76 x 49 (29 7/8 x 19 1/4)
Museum Ludwig, Cologne

who introduced them to her old-fashioned house full of unusual characters. She had two children: a son who owned an enviable collection of comics, and a daughter with a withered hand and a mental illness who, soon after the Blakes arrived, chased Shirley around the house with a carving knife. Two lodgers also occupied the house: a farm labourer who flatulated his way down the stairs at 5am every morning, and a one-legged Boer War veteran who had moved to the village to avoid company and find God. Mrs Loft was herself a devout Christian and insisted the evacuees share her puritanical regime: Blake's new life comprised enforced readings, wheat-scything sessions, trips to the meadow to fetch fertile molehill soil, and church – three times every Sunday. Feeling that his childhood had ended, he became consumed by fear, isolation and despair: 'One day I was so fed up that I tried to strangle myself, which of course you can't do. I was nine.'[2]

Peter and Shirley returned to Dartford in 1943 only to be re-evacuated the following year with an increase in the bombing (fig.2). This time they were sent to their grandmother's house in Worcester where Blake found a world almost as bizarre as Helions Bumpstead. His grandmother loved to stockpile: in her tiny house she kept twenty meat mincers and three flashy cocktail cabinets – all unused and pristine. In the spare bedroom she kept a mysterious trunk, which, one evening, Peter and Shirley mischievously opened to discover a hoarded assortment of beautiful toys. Caught in the act, the children were scolded for trespassing: how dare they play with gifts reserved for the future offspring of her youngest son? (He was just eighteen, the youngest of four, and away at war.) At least in Worcester Blake was able to pursue his interests. He joined the 'ABC Minors' a Saturday morning cinema club for children where he could see all his favourite films. He pinned the badge proudly to his blazer.

Blake found a very different Dartford after the war. With 150 people killed and thousands of buildings damaged or destroyed, the town was traumatised. Now aged thirteen, he also found himself to have changed. He had developed a 'pathological' shyness and often pursued interests alone or in the company of his mother. They both shared a love of live entertainment and, in the years immediately after the war, they started to go to the weekly wrestling matches at Bexley Heath Drill Hall, and they would never miss the local circuses and fairs that resumed their tour of the regions. As part of a crowd, Blake could remain contentedly anonymous whilst indulging his increasing interest in bizarre spectacle. He loved to observe the astonishing performers and admire the gaudy billboards announcing exotic entertainments.

Despite his growing interest in the visual world, Blake had never demonstrated any particular aptitude for art. Nevertheless, in 1946, having failed the entry exams for Grammar School, he was accepted by the Junior Art School of Gravesend Technical College. Still wearing short trousers, he travelled each day from Dartford to Gravesend on the bus: 'I went straight from childhood to art.' In his first life class, he faced the astonishing figure of Quentin Crisp, naked, with blue hair and fingernails. The teaching methods, however, were more conventional. Blake developed skills in a number of traditional areas including life drawing, typography, roman lettering, illustration, graphic design, silversmithing and joinery. He also drew influence from Enid Marx – a specialist in popular art who taught at the school for a term. Marx sought to revive traditional British arts and crafts such as barge painting, patchwork quilts, tattoos and sign

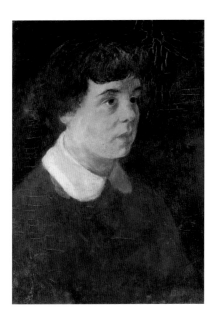

PORTRAIT OF SHIRLEY BLAKE
1950 [4]
Oil on cardboard
45.7 x 31.1 (18 x 12 1/4)
Shirley Blake

writing. In her influential book, *English Popular and Traditional Art* (1946), she bemoaned how 'the "innocent eye" is disappearing in England . . . the country craftsmen are dying out and with them that individuality in design and decoration that gave life to the old popular art'.[3] Her ideas were shared by many artists of all political persuasions who responded to the war by retrenching into 'ye olde' England's rose-tinted past. Blake had already expressed an interest in fairground billboards, and had started to collect hand-crafted objects on his way home from school. He had discovered an old junkyard running alongside Gravesend Railway Station where he found a cornucopia of curios, knick-knacks, and primitive paintings all painstakingly decorated, peculiarly British and at a price to suit his pocket-money budget.

Outside of school Blake continued his double life as a pop-cultural connoisseur. He added music to his ever-growing catalogue of specialisms, having discovered his dad's collection of swing records at the age of fifteen. Soon afterwards he joined Dartford Rhythm Club, where his love of modern American jazz was born. It was at this time that he became increasingly attracted to all things American. He admired the cool attitude of American youths as expressed in films and comic books, and he began to experiment with his appearance. Taking a cue from the US servicemen based in Britain at the time, he got a crew cut in 1947 – a shocking move. He also searched the shops desperately for a pair of denim jeans. Unable to find a pair anywhere, he made his own version by dismembering a blue cotton boiler suit. To complete the look, he wore badges to proclaim his allegiances to various youth clubs, and sported one of his own hand-painted ties depicting sexy American actresses and pin-ups. Although shy, he was confident in his interests and desperate to be cool.

In the summer of 1949 Blake's image took a severe knock. He suffered a horrific bike accident, lost three front teeth and endured thirty-seven stitches to his face. Finding it hard to accept his disfigurement, he refused to wear his false teeth. At an age when his interest in girls was developing, these injuries came as a bitter blow to an already shy young man. Blake's schoolwork, however, only grew in confidence. His graphic designs were particularly competent, as were the portraits of himself and his family, which he painted in oils. While studying for his National Diploma in 1950 and with four years of art school behind him, Blake decided that he wanted to be a painter. His tutors warned against such an uncertain career, advising him to pursue graphic design. He dutifully applied to study graphics at the Royal College of Art, but included a small oil portrait of his sister to support his portfolio (fig.4). Much to his delight, the College noticed the potential of the portrait and offered him a place on the painting course. But in 1951 he was called up for National Service; his place was deferred. He became a teleprinter operator and was posted to various camps across the country. Art took a backburner in these 'two dead years', but a rare and notable work of this time is *Self Portrait in RAF Jacket* c.1952–3 (fig.1). Blake was a loner in the ranks, but in this escapist work he presents himself as a confident, unblemished ringmaster presiding over a circus world far more exciting than humdrum officialdom.

At the Royal College, Blake was part of the generation that was 'extremely glad to be there: we were getting grants and were the first generation of working-class students who had that sort of privilege'. He worked and played hard. In the daytime he was taught by some of the leading figurative painters of the day, including Ruskin Spear, John Minton and Carel

Peter Blake at the Royal College
of Art, 1956 [5]

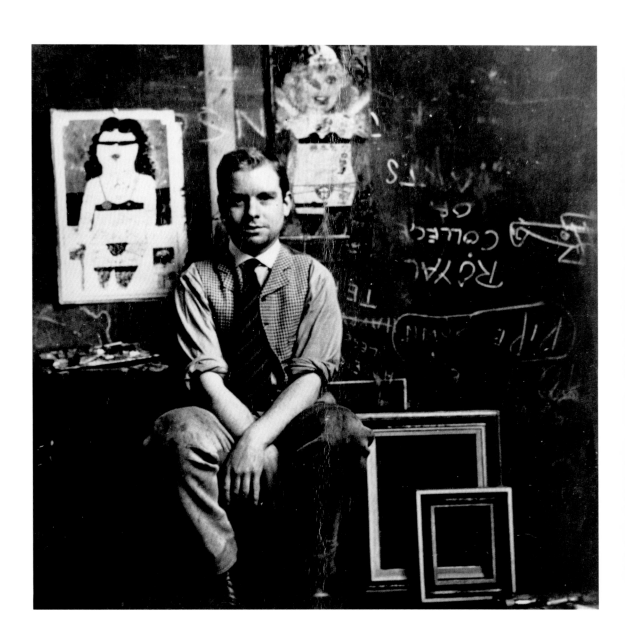

Bernard Perlin
ORTHODOX BOYS 1948 [6]
Tempera on board
76.2 x 101.6 (30 x 40)
Tate

Weight, who expected their students to learn traditional skills and to emulate the work of Renaissance and Post-Impressionist masters. In his spare time Blake continued to pursue his own interests. He grew his characteristic beard to cover his scars, and, consequently, socialising became easier. He went partying and clubbing with fellow students Joe Tilson and Richard Smith, and also spent a great deal of time visiting art exhibitions. During his college years, a number of shows of American art were staged in London. He drew influence from American Symbolic Realist artists such as Ben Shahn, Honore Sharrer and Bernard Perlin, whose work he had seen in a show at the Tate in 1956 (fig.6). They painted scenes of ordinary working-class life precisely, yet with a certain decorative magic. At the Institute of Contemporary Arts he saw work by the American cartoonist Saul Steinberg and was immediately impressed by his quirky calligraphy. He also attended lectures at the ICA organised by The Independent Group, a body of forward-thinking artists, architects and theorists, including Richard Hamilton and Eduardo Paolozzi, who championed a closer relationship between art and popular culture.

At the Royal College, Blake developed a highly original body of work, which drew on his interest in popular culture and his childhood experiences. Believing the war to have stolen his youth, he felt compelled to reinstate and re-evaluate it by painting pictures of boys and girls pursuing their leisure interests. He naturally turned to portraiture to represent anonymous, somewhat solemn children who often assume a static, formal, full-frontal pose. But the deceptive straightforwardness of these compositions only partially masks a more complex undercurrent reflecting the artist's dislocated past and the inherent complexities of growing up. The children

he depicts are impossible to define. Based loosely on family photographs, they seem to represent the artist – they share his interests and his body shape (their disproportionately large heads derive from a graphic design trick learnt at Gravesend to increase expressivity). Yet they also embody more universal childlike qualities of both wanting and not wanting to be part of the adult world. They appear strangely ageless – at once exuding a puppy-fat innocence and an air of cocky, worldly knowingness – and, although they share their hobbies with us, they always keep their distance. In *Children Reading Comics* 1954 (fig.7), for example, the comics create a physical barrier that prevents us getting closer. The children's impenetrable stares are similarly deflective. For Blake, these children belong to a lost world only partially retrievable through bittersweet nostalgia, and through the paint, which appears ghostly in places, reinforcing the ethereality of memory. The significance of the 'children paintings' also resides in Blake's depiction of printed graphics, reflecting his training in graphic design and his love of typography. His use of comics anticipates the widespread appreciation of the subject in the 1960s.

The tutors at the Royal College often set subjects for their students to paint, awarding a prize for the 'best' work. They tended to prescribe religious or time-honoured subjects, much to the horror of most students. But Blake enjoyed the challenge of working to a brief, adapting it to fit his increasingly inventive series of childhood paintings. In 1955 the students were instructed to paint 'The Entry into Jerusalem'. Blake prefixed the title with 'The Preparation for' so that he could stage a group of children getting ready for their school play (fig.8). The painting unveils his new, ambiguous use of space: the street upon which the children stand simultaneously represents the

CHILDREN READING COMICS
1954 [7]
Oil on hardboard
36.9 x 47 (14 ½ x 18 ½)
Tullie House Museum and Art
Gallery, Carlisle

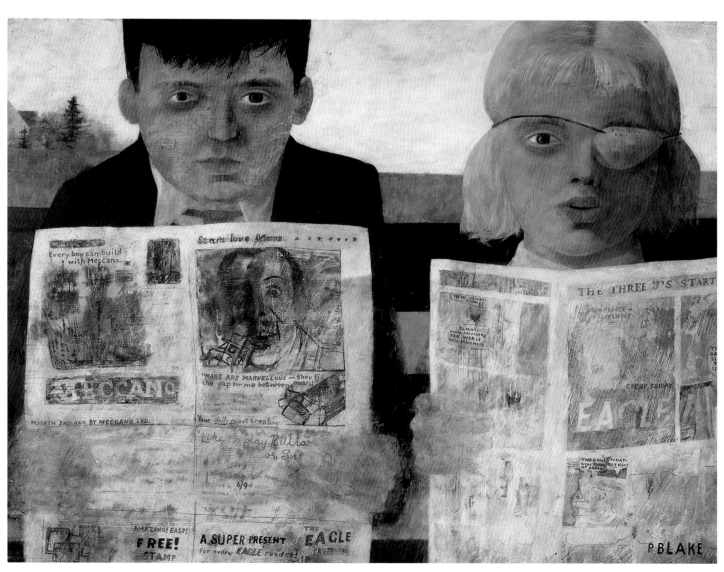

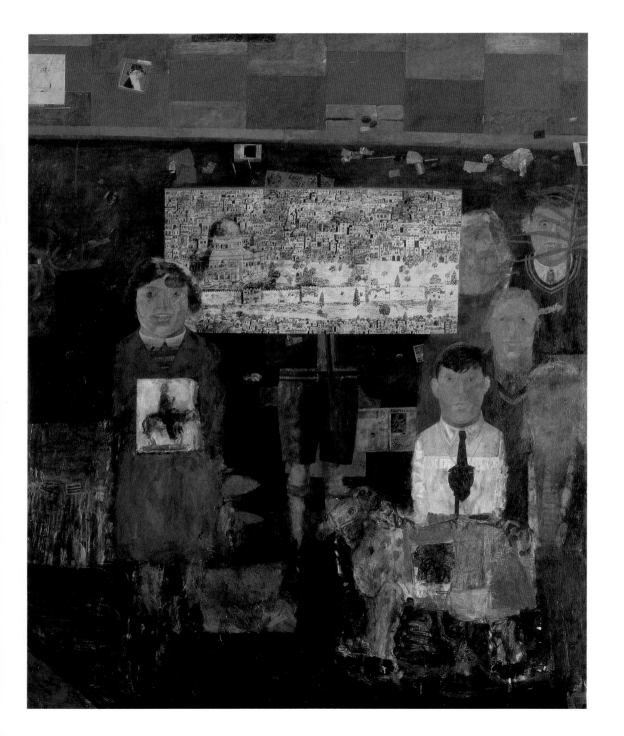

THE PREPARATION FOR THE ENTRY
INTO JERUSALEM 1955–6 [8]
Oil on hardboard
127 x 102 (50 x 40 ⅛)
Royal College of Art Collection

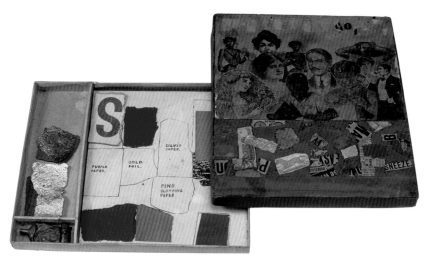

MAKE YOUR OWN COLLAGE
c.1955 [9]
Paper box, paper collage and
tube of glue
17.2 x 15 x 1.5 (6 3/4 x 5 7/8 x 5/8)
Collection of the artist

horizontal stage, the vertical backdrop and the rising curtain. The quadrangular patterning of paving stones and meticulously painted printed materials adds to the flattening effect and creates a playful chequerboard, an enclosed world. The painting also reveals a recurrent characteristic of Blake's work: facial disfiguration. Features are cropped by the limits of the canvas, obscured partially or entirely by objects, or barely sketched in at all. This subconscious tendency touchingly references both Blake's bike accident and his shyness, and also reflects his love of disguise, masking and performance as observed at wrestling matches and circuses.

The themes of *The Preparation for The Entry into Jerusalem* are developed further in another set-subject painting, *On the Balcony* 1955–57 (fig.15, p.21). For this work Blake collected pictures of scenarios involving balconies. The final painting features a cast of kids each clutching or acting out one of these images. It is the most ambitious work of the series and is widely recognised as 'an extraordinary conception for the year 1955 and a small encyclopaedia of themes which were later taken up by both English and American Pop'.[4] Its significance is investigated on pages 18–21.

Blake's paintings of 1955 feature mass-produced objects painted so accurately that you could almost pick them off whole. This *trompe-l'oeil* illusionism stems in part from an admiration of Stanley Spencer and Northern Renaissance masters such as Hans Memling, who could paint people and objects with a magical hairsbreadth precision. But it also derives from his discovery of collage. In his final year at the Royal College, Blake shared a flat in Chiswick with the abstract painter Richard Smith. Smith's friend, Jasia Reichardt, had relatives who knew the German collagists Raoul Hausmann and Kurt Schwitters, and

it was through this connection that Blake discovered the technique for the first time. He began to experiment with collage at home. At first he made tiny abstracts using bits of coloured sugar paper and tin foil, but he quickly realised the potential of printed papers. He started to collect Victorian engravings, playing cards, advertisements – anything that caught his eye – so that he could cut and paste them together onto two- and three-dimensional surfaces to create fantastical and bizarre incidents on a small scale (fig.9). Collage was a 'revelation' to Blake. In his paintings he used oil to capture reality, but in his collages he could use pieces of reality to create magic.

Knowing his tutors would otherwise disapprove, Blake used collage only sparingly in the daytime. He incorporated it discreetly into a number of drawings and panel paintings based on imaginary female sideshow entertainers and 'freaks', reflecting his love of the circus. *Loelia, World's Most Tattooed Lady* 1955 (fig.10) is one of the most striking works from this series and, although it reveals the influence of Otto Dix's grotesque realism, its primary source is popular art. Wishing to emulate the fairground billboards that had always attracted him, Blake intentionally assumed the cack-handedness of a second-rate sign writer to make the panel. He added gashes and graffiti to heighten its authenticity, and this sense of imperfection is reflected in the strange figure of Loelia, who appears to have seen better days. Yet Blake, aware of his own defects and eccentricities, portrayed her with much empathy, celebrating her flaws. He even gives her special powers: she has six arms like Kali, the Hindu goddess of destruction. At first glance, Loelia, in her bejewelled g-string and conical bra, seems a million miles away from the boys and girls of Blake's other college work. Yet her squat, full-frontal pudginess and big eyes seem more

LOELIA, WORLD'S MOST TATTOOED
LADY 1955 [10]
Oil and collage on panel
74.9 x 26.7 (29 ½ x 10 ½)
Collection of Fleur Cowles

SIRIOL, SHE-DEVIL OF NAKED
MADNESS 1957 [11]
Oil and collage on panel
75 x 21.6 (29 ½ x 8 ½)
Private Collection

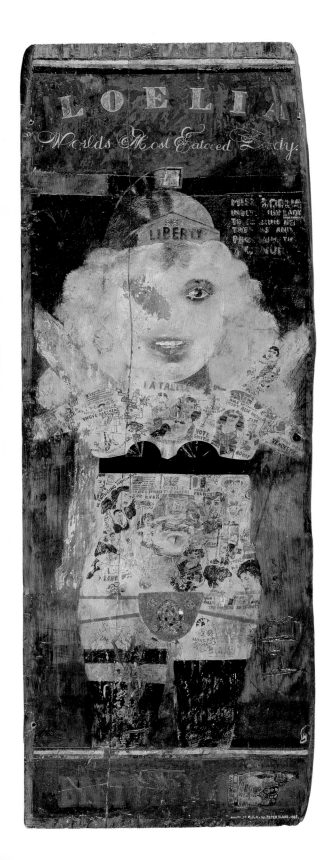

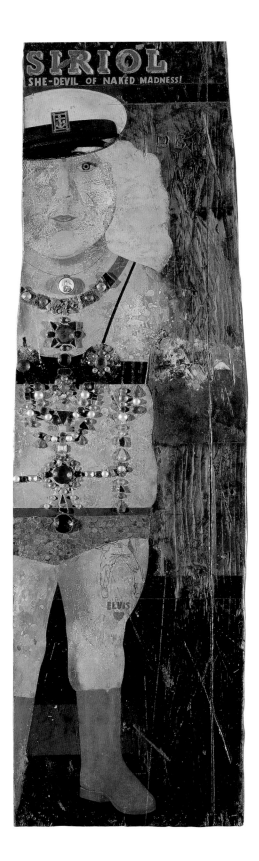

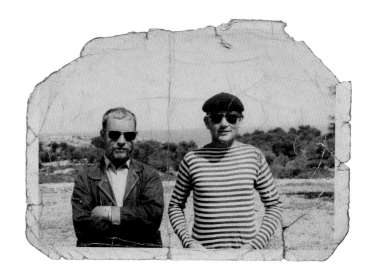

ITALY 1957 [12]
Black ink
26 x 33.7 (10¼ x 13¼)
Private Collection, courtesy
Waddington Galleries

Opposite:
Peter Blake and Joe Tilson,
Spain, 1957 [13]

innocent than erotic and, just like the children with badges, her interests (and those of the artist) are emblazoned upon her body. Blake was fascinated by the popular art form of tattooing – not surprisingly considering his preoccupation with the surface of things and in finding a beauty in scars.

Blake's extraordinary vision earned him a coveted First Class Diploma at the end of his studies in 1956. He was also awarded a Leverhulme Research Award to study popular art in Europe (fig.13). He had never before been abroad and felt honoured to embark upon his very own 'grand tour'. He worked his way around the fine- and popular-art museums of Holland, Belgium, France, Italy and Spain, filling in the gaps of his art-historical knowledge on the way. He also met up with friends, got drunk, went to gigs and wrestling matches, travelled with a circus in Italy (fig.12), searched for Picasso in Nice, and finally found a real pair of jeans. The intensity of his experiences is reflected in the work that he produced on the trip. He made quick pencil or ink drawings, occasionally of famous landmarks such as Sacre Coeur, but often of fleeting views from the car window, or of random objects like ashtrays and postcards that were to hand while he was resting in cafés. The few tiny paintings that he made similarly avoid the monumental in favour of the local and the transient – pebbles on a beach, a lost shoe, a matchstick – the overlooked debris of the tourist trail. The trip was also an opportunity for Blake to enlarge his collection. Wherever he went he picked up tickets, postcards, fly posters, chip packets and advertisements – anything of visual or typographical interest that might be of use for future work. Exhausted but exhilarated, Blake returned to London in 1957, his bag full of source material, his education complete, his head full of ideas.

On the Balcony (fig.15) was Blake's first work to receive significant critical attention. Two art critics – Richard Coleman and Robert Melville – were particularly supportive in his early years, helping to establish his reputation as an innovative young painter. This section intersperses their evaluations of *On the Balcony* with Blake's views as expressed in a recent conversation with the author.

ROGER COLEMAN *Blake's world centres about a few recurrent sorts of subject matter, his most constant subject is, I suppose, the small child in an urban setting, but please do not get all steamed up about the hell of the back streets, they are not, and Blake is not concerned with those values. He uses children, kids would be a better word, as a kind of prop upon which he hangs the stuff that interests him; the image of the small boy, his coat emblazoned with badges, meticulously painted, that proclaims him everything from an ABC Minor to a member of the Dog Spotters Club . . . In one of his more ambitious pictures,* On the Balcony, *the children sit on chairs on a rubbish-strewn lawn holding reproductions, paintings, and photographs of the picture's subject; they range from the Royal Family on the balcony of Buckingham Palace on VE Day to Manet's famous* 'On the Balcony'. *All these things and a bit of private mythology thrown in for good measure, painted with a humour and precision that makes nonsense of much contemporary* trompe l'oeil *painting.* [1956][5]

PETER BLAKE As part of my diploma at the Royal College I was given a set subject between my second and third years. It was the first opportunity for me to paint an 'Important Picture'. I had the whole summer to work on it and it had to be four feet by three – I don't think I had ever painted on that scale before. My version of 'on the balcony' is a continuation of my earlier pictures of children. I started by collecting references to 'on the balcony' and soon realised there were many. I wanted to get them all in and so I borrowed a device from a painting called *Workers and Paintings* by the American artist, Honore Sharrer [fig.14]. She painted a row of manual workers holding up their favourite paintings. In 1956 there was a show at the Tate of the American Realists. Honore Sharrer was advertised as being in the show, but when I went to see it the picture wasn't there – it had been excluded for being too political – and so I asked to see it. I blatantly borrowed this device as a way of presenting other information.

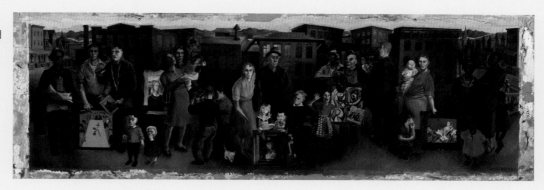

Honoré Sharrer
WORKERS AND PAINTINGS 1943 [14]
Oil on composition board
29.5 x 94 (11 5/8 x 37)
The Museum of Modern Art, New
York. Gift of Lincoln Kirstein

COLEMAN *Very often Blake's pictures are littered with the small objects of our urban civilization, the things that pass through our hands a dozen times daily, the cigarette pack, the detergent box, sweet wrappings, match-boxes, bus tickets, and so on; the world of the throw away object. Blake transforms these things into images of the most compelling sort so that we look at them a little harder next time just to see they are as real as he makes them.* [1956][6]

BLAKE I once made a painting called *Litter* [1955], which is almost a portrait of litter really. Like the badges and the holding up of pictures, litter is another way of giving further information. Again, when I went travelling in Europe there wasn't much that I could afford to collect, and so it came down to litter eventually – I would tear posters off walls, pick up cigarette packets and match-boxes and keep wrestling tickets. I like the idea of fragments.

ROBERT MELVILLE [On the Balcony] *is also a metaphor for the act of 'coming out into the open', of acknowledging what one stands for ... One's first impression is that [the children's] teacher has been enquiring into their private lives and has asked them to pose for a photograph whilst in the act of displaying the sort of thing they pin up on their bedroom walls, but a closer look at the mixture of magazine covers, newspaper photographs, badges and printed packages reveals little samples of 'high paste' and action painting and a reference to the death of John Minton and to [John] Bratby's kitchen table still-lifes which indicate that the children are, so to speak, acting on his behalf ...* [1962–3][7]

BLAKE I suppose my interest in the world of children came from the fact that I had such a complicated childhood. In a way I wanted to bring it back to make it better. The children in *On the Balcony* are like tiny adults. They are certainly odd: almost everyone I paint has an oddness – there is a subtext usually. I based

ON THE BALCONY 1955–7 [15]
Oil on canvas
121.3 x 90.8 (47 ¾ x 35 ¾)
Tate

the figures on family photographs of my sister and brother, but although they are from people they are not portraits – they are 'children'. I learnt from studying Graphic Design at Gravesend that you could trace and copy from photographs or printed material. But at the Royal College it was definitely illegal. I never admitted to using them, and if a tutor came round I would sit on them very quickly! Incidentally, I have kept some of the fragments for this painting – a few photographs and the magazine cover from *Life*.

MELVILLE *… this somewhat ambiguous device has its formal counterpart in the flattened spatial effect, which suggests both a patch of grass and a green baize notice board … [1962–3]*[8]

BLAKE I used the device of looking both down and across at the picture mostly for convenience – if you are painting a sheet of paper on the ground with someone standing next to it, perspective is going to be involved and it's going to be difficult. The device I used gives a very odd effect – you look straight across at the ground yet perspective is implied in certain places.

MELVILLE On the Balcony, *started when he was 23 and finished two years later, remains one of the most complex and successful studies in flat space that has been achieved in our time … His brilliant renewal of the traditional virtues of painting is reclaiming ground that modern art has abandoned. His paintings are for people.* [1969][9]

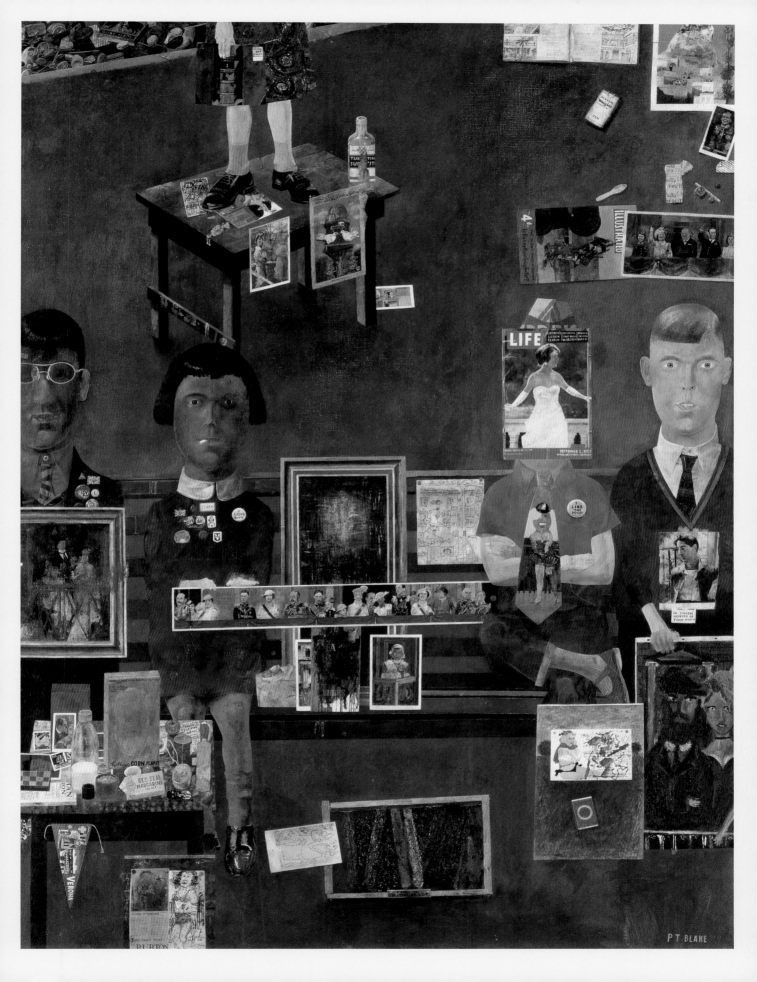

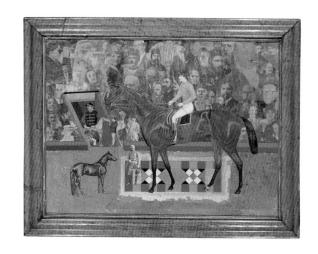

JOCKEY ACT 1957 [17]
Collage
72.4 × 87.6 (28 ½ × 34 ½)
Private Collection

HEROES

1957 was a year of consolidation and evaluation for Blake. Inspired by his studies and travels, he started to plan how he might make a living from his art. He deduced that it would be unwise to rely solely on the risky business of painting, and so resolved to divide his time between fine art, teaching and graphic design. It took a while to secure teaching and commercial contracts, thus leaving plenty of time for him to devote to his own work. It was during these relatively quiet years of the late 1950s that he produced a remarkable range of work that set a precedent for a younger generation of British artists in the early 1960s.

One of Blake's first tasks was to add the finishing touches to *On the Balcony* and, although he would return to the 'childhood' paintings from time to time, its completion marked the end of their intense production. However, his other favourite subject from college – the circus – remained prominent. In 1957 he made a series of collages, each featuring a different circus act (knife throwers, animals, human cannonballs and so on) performing in front of a ringside audience. Although the influences of Max Ernst, Kurt Schwitters, and the visual mayhem of collaged Victorian screens are discernible in the *Circus Act* works, Blake's increasingly skilful and original use of the medium is clear to see. *Jockey Act* 1957 (fig.17) is a typical work from this series. It offers an early glimpse of his interest in representing magical crowds of people from different times and places while reflecting his own love of watching from the sidelines. The composition of the piece – where performers and audience, foreground and background, are divided by a strong horizontal – would frequently recur in future works. Alongside the *Circus Act* works Blake continued to make collages and wooden panels featuring tattooed female fringe entertainers, such as

the quirky *Siriol, She Devil of Naked Madness* 1957 (fig.11) which features a bejewelled temptress who sports a seafaring cap to represent her love of travel.

Freed from the restraints of a formal education, Blake became more adventurous and began to blur the earlier distinctions of his practice. A marked development in both design and conception is seen in *Knife Thrower's Board* (fig.16), made just months after *Siriol* in 1957. A life-size pin-up of Blake's favourite star, Brigitte Bardot, was released in weekly sections by the gentleman's magazine, *Reveille*; he collected the parts and pasted them to a board, retouching her face by hand. Although collaged images of cutlery surround the star to recall the act of knife throwing, the overall mood of the painting is desire, not violence: Bardot is simply good enough to eat. Blake had grown up and so had his characters, Bardot's streamlined, coquettish pose replacing the fuzzy, take-me-or-leave-me frontality of her asexual predecessors, *Loelia* and *Siriol*. His use of collage had similarly matured. For Blake, collage was no longer a separate strand of his practice or an incidental feature of his paintings, nor need it comprise old-fashioned fragments, artfully arranged. Collage could be seamless and contemporary, and as prominent in his practice as Bardot was in his dreams.

A Technicolor image of Brigitte Bardot in a national magazine not only indicated the advancements made in British print technology, but also the increasingly liberal society it serviced. With the fog of post-war austerity lifting and an upturn in the economy, a new spirit of optimism was kindled, especially amongst the younger generation, who were desperate to start living. Blake was no longer alone in his love of pop music, films, pin-ups and fashion as imported from the States; he was now one of millions of devoted fans who followed heroes such as Bo Diddley, the Everly

Installation of Blake's work at the
ICA, 1960, featuring *Crazy Said Snow
White* 1959. On the wall (left to
right) are *Elvis and Cliff* 1959, *Sinatra
Door* 1959, *Girlie Door* 1959, *Drum
Majorette* 1957 and *Couples* 1959 [18]

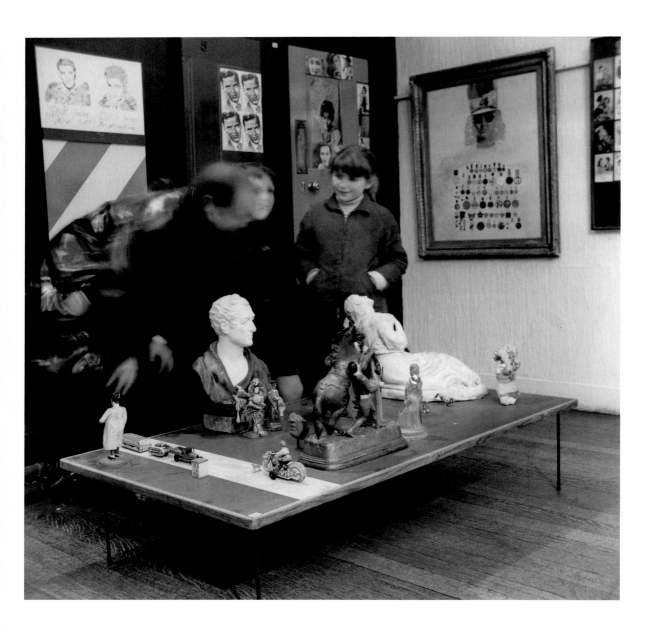

GOLD PAINTING (PIECE OF A
JAPANESE SCREEN) 1959 [19]
Gold leaf on canvas
93.4 x 63.2 (36 3/4 x 24 7/8)
Collection of the artist

Brothers, Chuck Berry, Little Richard, and collected the first vinyl records as they were released. Such was Blake's admiration for the entertainer Sammy Davis Junior that he painted a portrait of him in 1957, took it to the hotel where the star was staying, and left it in a bag with the receptionist. The painting has never been seen since.

Blake embraced popular culture in his work whilst maintaining a certain anthropological perspective. He noticed how the printed products of the new pop culture were the direct descendants of the popular art of the past. Just as billboards and signs occupied circuses and fairgrounds, so the new popular art forms – postcards and pin-ups – occupied the homes of fans and enthusiasts. However, Blake's deep affection for the past (be it last century or last night), and his belief in its influence on the present, bestowed even his interpretation of contemporary forms with a certain period charm. Unashamed of his allegiance to an unfashionable world of sentiment and reminiscence, he later reflected:

For me, pop art is often rooted in nostalgia: the nostalgia of old, popular things. And although I'm also continually trying to establish a new pop art, one which stems directly from our own time, I'm always looking back at the sources of the idiom and trying to find the technical forms that will best recapture the authentic feel of folk pop.[10]

1959 was a prolific year in which Blake tested a variety of formats to suit the two- and three-dimensional material he had amassed. Fascinated by the ornamental displays in people's homes, and drawing on the example of the oddball work of the American sculptor H.C. Westermann, he made a number of sculptures on a horizontal axis (fig.18). *Crazy Said Snow White* 1959 exemplifies Blake's sculpture of this

period. The piece, which takes its title from a Stan Freberg record, comprises an old coffee table upon which assorted miniature ornaments sit: some old, some new, some Eastern, some Western; always figurative, intricately decorated and precisely arranged. Collating miniature objects enabled Blake to create fantastical scenarios with a cut-and-paste effortlessness.

Blake's interest in sources of decoration within the home environment prompted his interest in the domestic Japanese screens that he saw on display at the Victoria & Albert Museum at this time. He responded with a whole series of wooden panels decorated with patterns in silver and gold leaf. Although these panels are the most abstract works of his career to date, they still derive from a figurative, domestic source (fig.19). Nevertheless, it was the humble noticeboard – used by thousands to display their favourite postcards – that presented Blake with the greatest source of potential. Although a noticeboard is implied in *On the Balcony*, only in 1959 did he take the groundbreaking decision to incorporate one directly. Why make a *trompe-l'oeil* painting when including the real thing enables a greater realism?

To make *Couples* 1959 (fig.20) Blake selected twenty-four old-fashioned romantic postcards from his vast collection and attached them to the green baize in a carefully constructed grid. In moving away from cut-and-paste to a technique whereby unaltered images occupy their own space, he revealed his love of rectilinear patterning and his utmost respect for the originals. He loved the way that postcards could level any image – be it a cutesy couple or a work of art – to the same scale and cost. In praise of this popular form, he would later start a series of large-scale paintings in which seemingly inconsequential postcards assume monumental proportions. Real postcards also feature

COUPLES 1959 [20]
Collage on notice board
89 x 59.7 (35 x 23 ½)
Collection of the artist

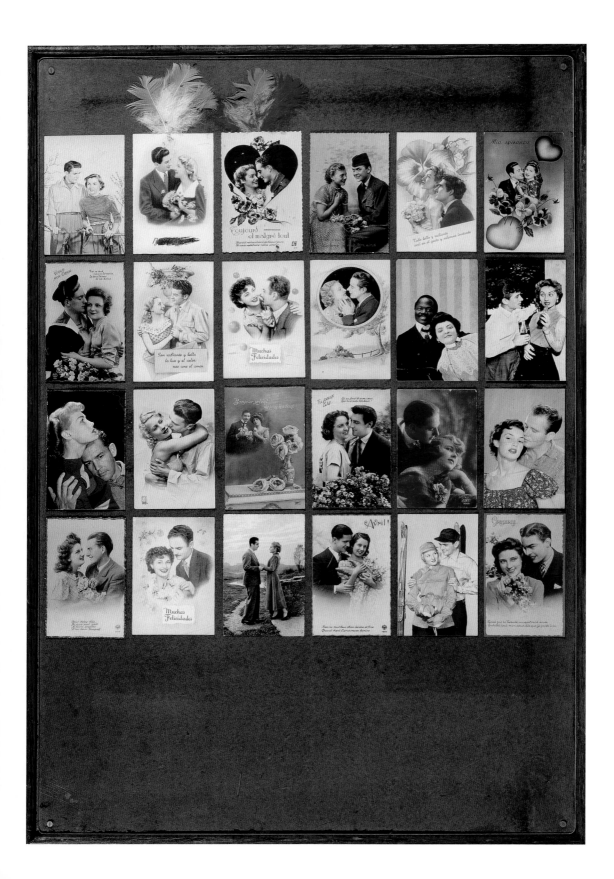

THE FINE ART BIT 1959 [21]
Enamel, wood relief and collage
on board
91.4 x 61 x 2.5 (36 x 24 x 1)
Tate

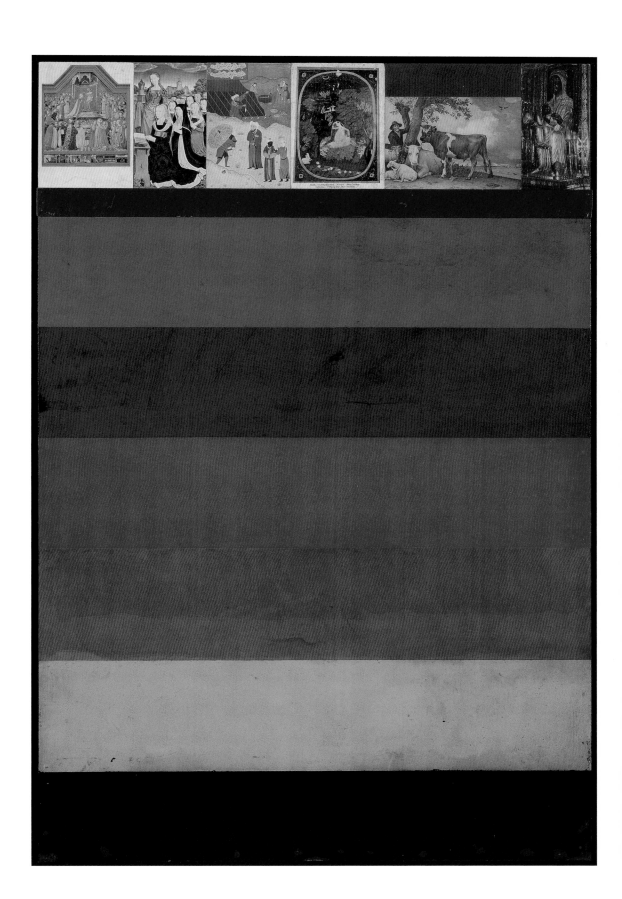

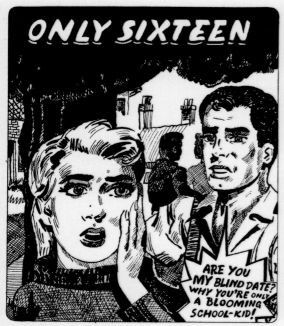

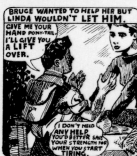
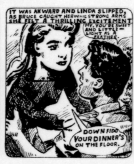
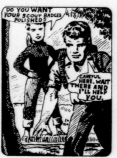
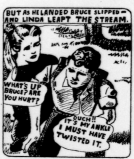
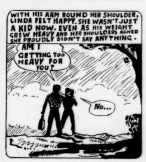
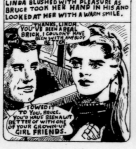
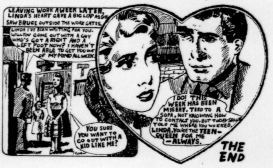

ONLY SIXTEEN
Cartoon strip, published in the Royal
College of Art magazine *Ark*, no.25,
Spring 1960, p.29 [22]

GOT A GIRL 1960–1 [23]
Oil paint, wood, photo-collage
and record on hardboard
94 × 154.9 × 4.2 (37 × 61 × 1 5/8)
The Whitworth Art Gallery,
The University of Manchester

in *The Fine Art Bit* 1959 (fig.21), where six miniature masterpieces from Eastern and Western art form a neat row atop a striped board, to comment on the work of artists past and present. To get back to basics and to brighten things up, Blake used enamel paint in primary colours – a deliberate and radical snub to the contemporary trend for the painterly application of sludgy browns and pinks. Yet, despite the fine-art allusions, popular art remains at the heart of this work: the coloured stripes may refer to American Post-Painterly Abstraction and the flag paintings of Jasper Johns, but they equally recall fairground decorations.

The process of making the noticeboard works led Blake to assimilate a whole range of domestic surfaces upon which contemporary imagery is commonly attached. The bedroom wall – a site for countless shrine-like montages – prompted a series of 'Walls' dedicated to stars such as Cliff, Elvis and Kim Novak. For each of these works, Blake arranged close-up publicity shots of a particular star with a movie-reel repetitiveness across the top of a brightly coloured board, thus reinstating the composition of *The Fine Art Bit* 1959 whereby a row of images sits atop a decorated surface. This device also recalls *Children Reading Comics* 1954, where the children peer over their screen-like comics, but in this case the coloured glossy stripes of paint shield the star, deflect our voyeurism and remind us of a fan's futile attempts to possess an unobtainable idol.

The two-dimensional world of printed imagery is one of the few ways through which fans can regularly 'meet' with their idols. Blake's awareness of this on-the-surface relationship informed his interest in household doors – their panelled surfaces provided the perfect backdrop for his tidy and compartmentalising approach to collage. Often he would work on

real doors, as in *Locker* 1959 (investigated further on page 36–7). Doors can enable or prohibit entry, and in Blake's juxtaposition of doors and women one grasps a certain frustration in relation to the proliferation of female imagery in society but the lack of any real-life satisfaction. For *Girlie Door* 1959 (fig.94, p.115), he attached pictures of beautiful women to a painted illusion of a door, thus further heightening the bittersweet fiction of having suitors at his door.

Although many of Blake's works of this period embody the male experience of admiration and love, he also wanted to understand its feminine counterpart. Despite his barren love life, he had many platonic relationships with girls, and his empathy with female experience is demonstrated in a number of works, including one of the humorous cartoon strips that he contributed to *Ark*, the Royal College of Art magazine. *Only Sixteen*[11], featuring a girl called Linda who goes on a blind date with a boy named Bruce and eventually finds love, faithfully simulates the genre of teenage comic-book romances (fig.22). Blake was also fascinated by the female obsession with idols. The collage-construction *Got a Girl* 1960–1 (fig.23) takes its title from a song by The Four Preps. The song describes the frustration of a boy who, in trying to kiss his girlfriend, breaks her locket and releases the images of her favourite pin-ups. By including the record in the top-left corner, Blake hoped that viewers would listen to the song whilst looking at images of the girl's heroes. In doing so he effectively created a primitive pop video, pointing the way forward once again.

At about this time Blake's work captured the attention of the art critic Lawrence Alloway – who had supported the Independent Group's interest in popular imagery. One evening, over dinner, Blake recalls, Alloway raised the question as to whether the

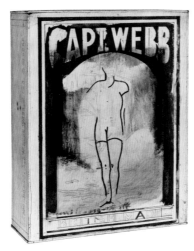

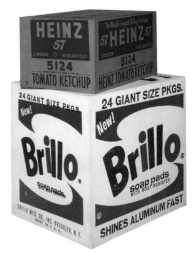

CAPTAIN WEBB MATCHBOX
c.1960–1 [24]
Gouache and pencil on wood and
hardboard
40 × 29 × 10.5 (15 3/4 × 11 1/2 × 4 1/8)
Private Collection

Andy Warhol
HEINZ TOMATO 1964
Painted wood
21.6 × 39.4 × 30.5 (8 1/2 × 15 1/2 × 12)
BRILLO 1964 [25]
Painted wood
44 × 43 × 35.5 (17 3/8 × 16 7/8 × 14)
Tate. Lent by the Froehlich
Foundation, Stuttgart 2000

new genre of pop music had any equivalent in fine art. Concluding that Blake's work was its closest relative, he consequently coined the term 'Pop art', not to abbreviate the broader genre of popular art, but to denote Blake's particular branch of fine art. There are many interpretations as to how Pop art started in Britain, but this is how Blake remembers it. He acknowledges his Independent Group predecessors and affirms the direct influence of the American painters Jasper Johns and Robert Rauschenberg, but he owes much inspiration to his artisanal upbringing and interests. 'I was really just painting what I was about, the person I was and the things I knew.'[12]

Blake's influence extended to a slightly younger generation of artists that included Derek Boshier, Pauline Boty, David Hockney, Allen Jones, R.B. Kitaj and Peter Phillips, all of whom were studying at the Royal College at the turn of the decade. Each developed a highly personal figurative style that retained a certain respect for the traditions of painting and drawing but which incorporated abundant references to popular culture. Traces of Blake's use of popular art and typography, primary colours and rectilinear patterning can be discerned in some of their work, and, like him, many came from modest backgrounds – a factor that he believes contributed to their inclusion of 'vulgar' subjects in fine art. The surfaces of many of their works are packed with commodities – perhaps a subtle reaction to their experiences of rationing. The artists exhibited their work together throughout the early 1960s, and gradually became known as a group. They had no collective agenda or manifesto – they were just a circle of friends with a shared interest in the contemporary world.

1961 was a significant year for Blake and British Pop art. The year began with the BBC broadcast of Ken Russell's film *Pop Goes The Easel*. Progressive for its time, this unconventional documentary featured the art and lifestyle of four Pop artists in turn – Blake, Boshier, Boty and Phillips – and introduced their work to the nation. We find Blake asleep in his bed, surrounded by pin-ups and dreaming of Bardot. Later we see him at a wrestling hall, a fairground, and perusing London markets in search of objects for his work. In the autumn, his painting *Self Portrait with Badges* 1961 (frontispiece) won first prize in the Junior Section of the Third John Moores Liverpool Exhibition. The work was immediately lauded as a unique and honest expression of personal allegiances both past and present. In style and content, it recalls his pictures of children, but here an adult Blake takes centre stage in formal pose, illustrating his commitment to a grand tradition of portraiture. The softly painted scenery signifies a patriotism for this 'green and pleasant land', but his attire is American. Standing solemnly in an armoury of badges like a veteran on Remembrance Day, he appears to have gone a little too far. Nevertheless, others, including The Who (known for a while as 'The Who: The Pop Art Band') were influenced by his quirky attire.

Considering the breadth of references in Blake's work, it is hardly surprising that its appeal resonated beyond the art world. In February 1962, *The Sunday Times* launched the first-ever colour supplement. Its editor, Marc Boxer, keen to employ the vision of contemporary artists to further the magazine's progressive profile, included a feature on Blake. Yet, despite this increased media interest, Blake needed to supplement his income by teaching part-time at St Martin's, Harrow and Walthamstow Schools of Art throughout the early 1960s. His teaching philosophy was to preach what he practised. The late Ian Dury warmly remembered his inspirational, eccentric teacher:

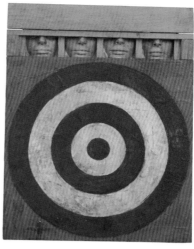

Jasper Johns
TARGET WITH FOUR FACES 1955 [27]
Assemblage: encaustic on newspaper
and collage on canvas with objects,
surmounted by four tinted plaster
faces in wood box with hinged front
85.3 x 66 x 7.6 (33 ⁵/₈ x 26 x 3)
The Museum of Modern Art, New
York. Gift of Mr and Mrs Robert
C. Scull

THE FIRST REAL TARGET 1961 [26]
Enamel on canvas and collage
on board
53.7 x 49.3 (21 ⅛ x 19 ³/₈)
Tate

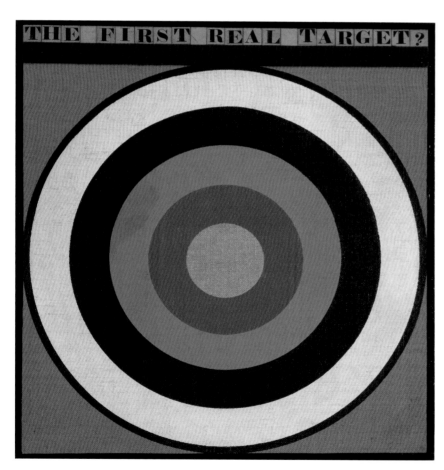

On a Wednesday night in early September 1961, Peter Blake walked into the third-year painting room at Walthamstow School of Art. Blue tab-collar shirt, silk paisley tie, herringbone jacket and gold beard. He looked like the front man of the modern art quartet. I was painting a humdrum scene in a slipshod manner and looking forward to going to The Bell.

'Do you like rock 'n' roll?' he asked.

'Yes.'

'Boxing and wrestling?'

'Yes, and tits and bums, gangsters, teddy boys, Jayne Mansfield and Marlon Brando.'

'Then why don't you paint pictures of what you like?'[13]

A jocular attitude pervades much of Blake's work, sometimes to the extent that the joke becomes the subject. In his initial piece of this kind, *The First Real Target* 1961 (fig.26), he questioned the art world's obsession with originality. His work had often incorporated images of targets and chevrons, and he knew he wasn't the first to include such wartime insignia – Jasper Johns had beaten him to it. To mock the notion that he had therefore somehow failed, he decided to win the race for being the first to incorporate a *real* target. The title is so crucial to the meaning of this work that he felt he had to spell it out – using wooden letters from a children's game to emphasise his playful stance. Humour aside, this work expresses Blake's competitive streak and the sense of rivalry he felt towards his American contemporaries. He felt that some of his most innovative contributions to the language of Pop art had been overlooked: his paintings and collages featuring Marilyn, Elvis and comic book imagery, for example, preceded the use of such subjects in American Pop by a number of years. He also viewed sculptures such as

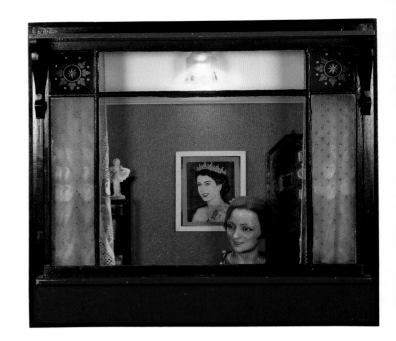

GIRL IN A WINDOW 1962 [28]
Collage construction
112.5 x 123.9 x 34
(44 ¼ x 48 ¾ x 13 ⅜)
Leeds Museums and Galleries
(City Art Gallery)

Captain Webb Matchbox of *c*.1960–1 (fig.24) as significant precursors to Warhol's interest in consumer packaging as expressed in his famous series of *Brillo Boxes* (fig.25).

In 1962 – a year in which the work of American Pop artists such as Andy Warhol, Roy Lichtenstein and James Rosenquist hit the headlines – Blake's irritation was further aggravated when he and a number of his fellow British Pop artists exhibited their work in New York for the first time. Their show at the Sidney Janis Gallery received savage reviews from the American critics, who perceived British Pop to be a second-rate imitation of its US counterpart. In fact, as Blake's work proves, British Pop had developed independently, in parallel with (if not earlier than) American Pop. It simply approached Americanisation from a completely different and distant perspective, leading to work that was more celebratory, intimate and less cynical in tone. Blake deeply resented America's monopoly on Pop. He refused to show in New York again, a self-imposed exile that lasted for decades, until 2002.

Back in England, Blake's popularity continued to grow. In 1962 he staged his first solo exhibition at the Portal Gallery. It was a small gallery that sold equally diminutive paintings and so Blake mischievously included his recent collage constructions, many of which marked an increase in scale and ambition. These wall-based pieces bridge his work in two and three dimensions. Objects are displayed in real space, yet access to this space is always thwarted by a closed window or door. The impact of these works is such that viewers cannot help becoming implicitly involved with the scenario: we are transformed into the outcast on the wrong side of a closed café door, its interior obscured by frosted glass; we feel uncomfortable when staring at the lone female figure in *Girl in a*

Window (fig.28). *The Toy Shop* (fig.29) is perhaps Blake's most awesome assessment of being on the threshold: the door remains frustratingly closed and the window offers a tantalising glimpse of a childhood paradise. Although (aptly) child-size, it accurately captures the cramped displays of the typical British high-street shop of the time. It is also autobiographical: the paint sets, flags, targets, masks, postcards and Elvis pictures build up a portrait of an artist whose childhood memories include forbidden toys in his grandmother's trunk. But despite the intentionally constructed barriers that he sets up in these works, establishing real space allowed him to construct a greater realism and to connect more intimately with his subject matter.

Blake once said: 'The thing about Pop is that you've got to get *inside* the popular culture of the time whether you're doing the thing historically, or working in the present tense. I've got to get right in with the pin-ups and Elvis . . . and inside every house that has plastic flowers and curtains.'[14] This statement indicates how fully he had achieved his ambitions as a Pop artist by the time he had made these works of 1962. Although Pop art was still in its infancy, he had already produced most of his major works in the genre. Never one to follow the pack, he was already considering his next direction.

THE TOY SHOP 1962 [29]
Mixed media, glass and painted wood
156.8 x 194 x 24 (61 3/4 x 76 3/8 x 9 1/2)
Tate

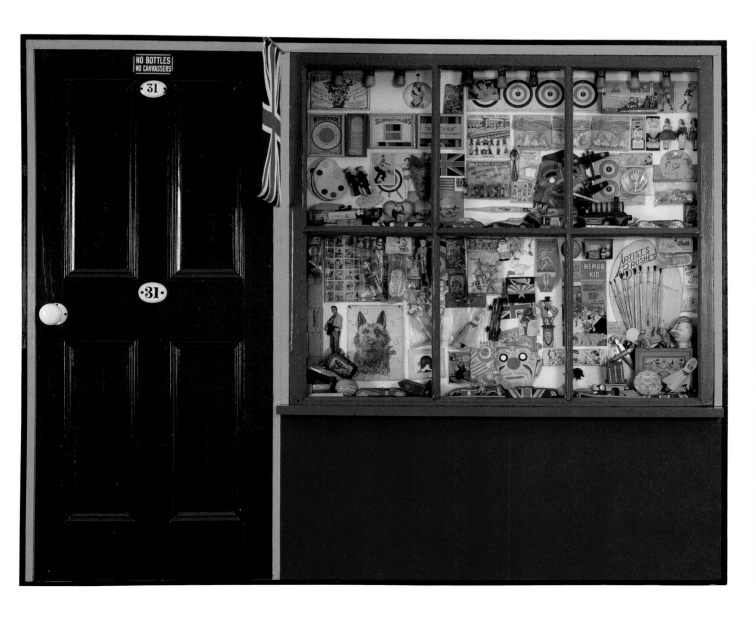

LOVE WALL 1961 [30]
Collage construction
125 x 237 x 23 (49 1/4 x 93 1/4 x 9)
Fundacão Calouste Gulbenkian

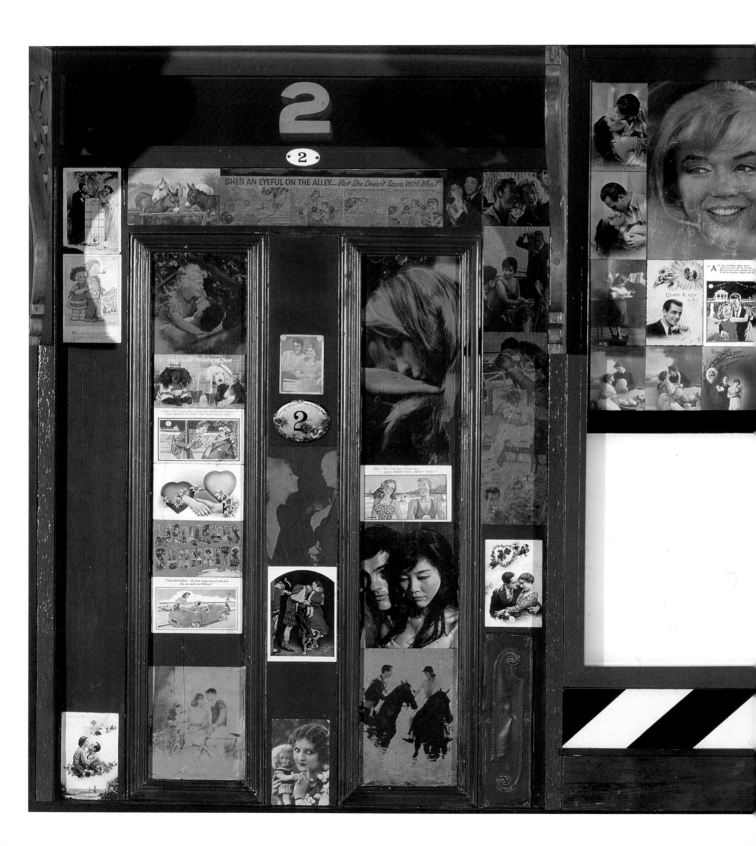

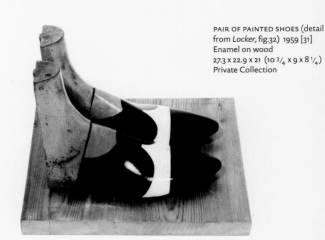

Locker is one of the many pioneering works made by Blake in 1959 – a year of enormous creativity and innovation. Although now relatively unknown, the work embodies many of the themes and techniques of his Pop art oeuvre. Here we reassess its importance and consider his work in three dimensions.

NATALIE RUDD Did you have a locker when you were in the RAF?

PETER BLAKE Yes. Your locker and your bed were your home, and the space around them was your space – you had to look after it. Lockers had to be incredibly formal: shirts had to be folded in a certain way and you were inspected most mornings. But you were allowed to put pin-ups inside the locker. Your locker became your world – you could put a picture of your mum up, or a tennis player or whatever. So making *Locker* must have been a throw back to that.

NR Where did you find this locker?

PB There was a junk shop on Chiswick High Road called *The Old Cinema*. It sold lots of ex-military stuff and one day they were selling off a bunch of old lockers. One of them had been painted bright blue: it looked beautiful and so I bought it. At first I used the locker as my wardrobe, and then, because I was making the first Pop art things in the space around it, I slowly thought, 'Well, this could be a work of art too.' For me to use the locker was quite a breakthrough. It was made at the same time as *Couples*, and one of the main breakthroughs I made in my branch of Pop art was the recognition that you could use real objects.

NR Were you aware of Duchamp's 'readymades'?

PB I wouldn't have been, but, looking back, I suppose *Locker* is a readymade in the same spirit as Duchamp's *Fountain*. When I first showed *Locker* at the ICA in 1960, I also put a pair of readymade shoetrees in the bottom of the locker. They were beautiful objects, used to keep your shoes in shape, and painted black and white with red socks [fig.31], so perhaps they were saying something about being in the RAF and not wanting to be.

NR How did you decide who to include in *Locker*?

PB There was a lot of selection involved – the people on the locker were those whom I had chosen to be there, so on the front is Brigitte Bardot, on the back is Kim Novak . . . it's saying 'These are the people I like'. I'd buy pin-up magazines like *Reveille* but I didn't have a collection as such; I'd just buy magazines to work from – they were disposable – so, I'd have had some images already but would have had to search for others, and the collecting would have come in at that point. Then it would have been a matter of arranging them. Both the front and back sections of the locker are quite formal and so I had to choose pictures to fit a certain space. It was very tightly designed and neatly stuck.

LOCKER 1959 [32]
Mixed media
152.4 x 76.2 x 76.2 (60 3/4 x 30 x 30)
Collection of the artist

NR *Locker* reveals a distinct longing for women. Is there an autobiographical connection?

PB Yes. I once revealed in an interview that I didn't sleep with anybody until I was twenty-nine. I think this was because of being scarred, and feeling I was ugly. There were many times when I might have done, and should have done, but I pulled away from it – it was a psychological thing really. A lot of the work of this time is simply about frustration and desire and whatever that madness was of being frightened.

NR With *Locker* you make a private space public by displaying pictures on the outside. Did *Locker* prompt you to make your famous collage constructions such as *Toy Shop* and *Girl in a Window* where interiors are also externalised?

PB Yes. It was another one of those breakthroughs that happened very naturally and it's now hard for me to remember how or why, but certainly the idea of looking through a window interested me. And in *Girl in a Window*, what I was trying to set up was a feeling of discomfort, that you were actually peeping and that someone was seeing you peeping.

NR You seem to adopt an almost painter-decorator method of applying paint in the collage constructions of this time. What prompted such a big change in your technique?

PB In 1961 I would have been painting *Self Portrait with Badges* at the same time as painting a window. So it wasn't the case that I suddenly went from one thing to the other. But, having decided to do those pictures, I acquired the doors and windows, often from skips and junkyards.

And then, the only way to paint a real door is to paint it well. My dad had taught me how to paint a door – the fact that you paint the moulding first and then each section to stop the paint dribbling . . .

NR So, you were striving for realism not only by using genuine articles but also in the way that you decorated them.

PB Yes. It was about changing personas – entering the mindset of a painter-decorator. But it was also about wood. I've always loved cutting and carving wood and using my hands. I probably made my first little peg carvings even before I went to Gravesend. Then at Gravesend I was taught woodwork . . . so it was also about keeping those skills going. My sculpture has never been fully recognised because it has never really been shown all together. So what I'm hoping to do in the future is to show it together in the hope that it will be taken more seriously.

NR It seems natural that you should have kept hold of *Locker* for so many years; it's become a part of the furniture in your studio.

PB Yes. I still use it to store things. In the early days I'd really hold out to keep my work – even when people didn't want to buy it! Today it would be difficult to sell the locker because I do love it. But, like anything, if I were offered enough I would sell it because I'm a professional. I'd accept that it had to go – you barter, exchange, and you move on.

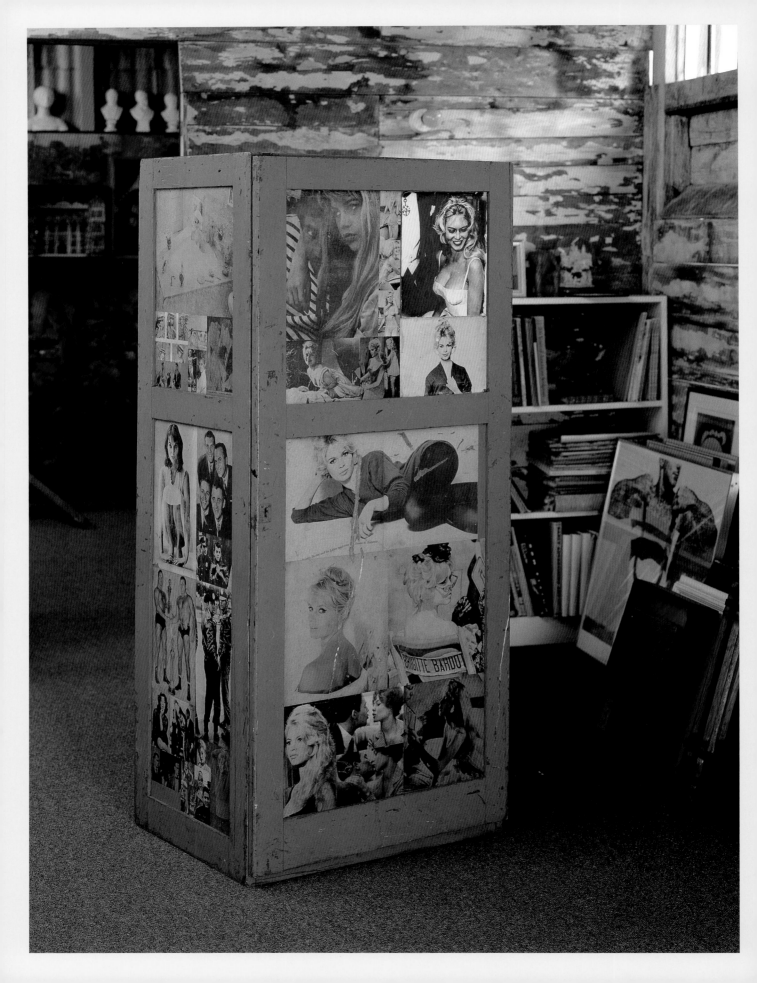

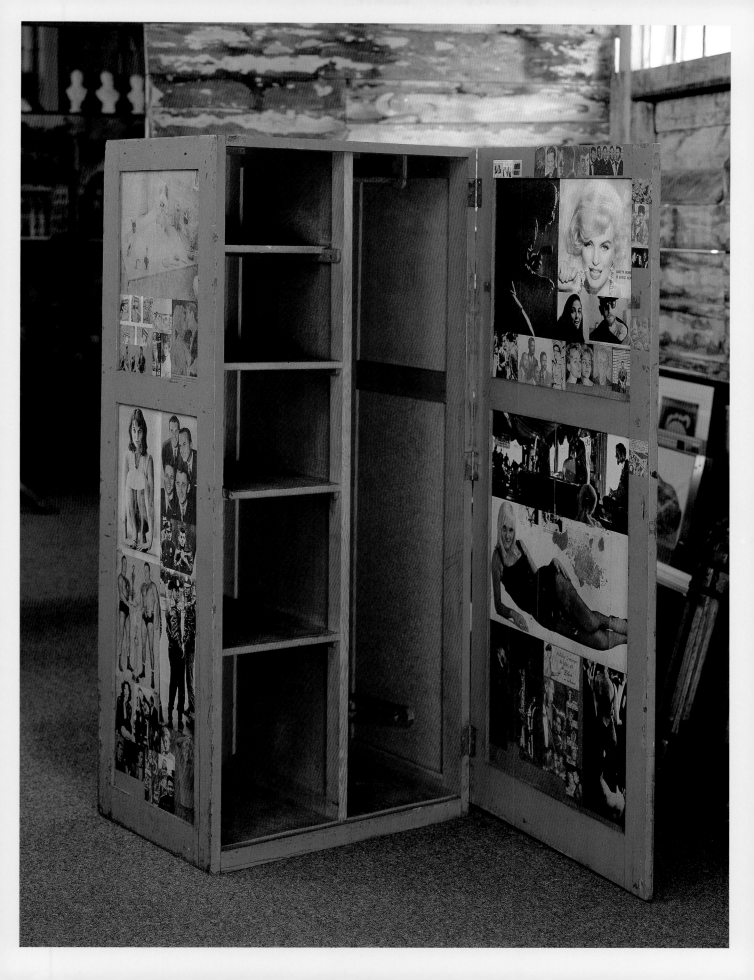

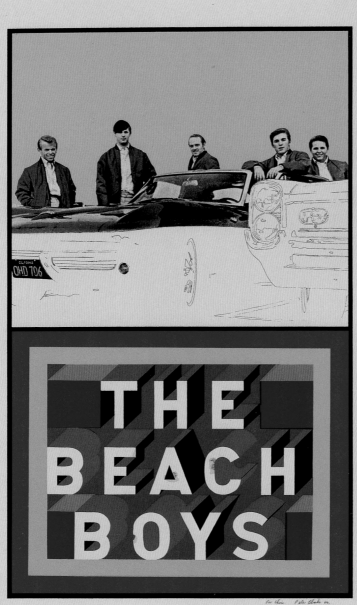

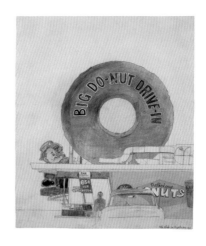

BIG DO-NUT DRIVE-IN 1963 [34]
Coloured pencil on paper
30.5 x 36.8 (12 x 14 1/2)
Private Collection

MULTIPLICITY

3

A chance meeting in the spring of 1963 brought Blake's bachelor days to an abrupt end. At a party he was introduced to a young Californian artist called Jann Haworth, the daughter of a Hollywood movie art director. Haworth, a student at the Slade, was organising an exhibition of work by students and recent graduates and she asked Blake to contribute. By July of that year they were married. Haworth moved into Blake's Chiswick flat and set up a studio alongside his to continue her work. She produced life-size effigies of celebrities constructed from textiles – an original take on British Pop for which she quickly gained recognition. Blake's emotional fulfilment coincided with his ongoing career success and, in the busy years that followed, he continued to diversify his practice and to enjoy being at the heart of things.

In November 1963, Blake was one of a number of artists commissioned by *The Sunday Times Colour Magazine* to 'record their responses to places with which they have an affinity'.[15] Haworth had unfinished business to resolve in Los Angeles and, to fulfil a lifelong ambition, Blake decided it was the place to visit. The trip was an incredible adventure, full of highs (listening to The Beach Boys for the first time whilst cruising along Venice Beach in a Corvette Stingray) and lows (losing all their money and learning of the death of JFK). Experiencing a culture he had only previously glimpsed in films and magazines, Blake discovered a world even more bizarre than he had imagined. He visited film sets, drive-ins and amusement parks, even a cemetery for animal celebrities complete with an eight-foot long grave for a movie-star snake. He witnessed the work of Mable Stark, an eighty-year old lion tamer, and he marvelled at Watts Towers – the 99-foot constructions made from mortar and broken crockery by the artist Simon Rodia. Wherever he went he made drawings,

six of which were later published in the magazine. Employing his characteristically economic and precise use of line, the drawings reveal his instant delight in the city: *Big Do-Nut Drive In* 1963 (fig.34) was sketched directly from his passenger seat in the Stingray. Since art school, he had carried a sketchbook so that he could spontaneously capture his immediate environment. Although his paintings and collage-constructions feature unidentified places, his drawings depict specific locations, and the thrill of visiting a new or exotic place only increased his urge to sketch. Los Angeles inspired him to such an extent that it would influence other areas of his practice for many years.

Blake's return to London coincided with the publication of his first major interview, in which he expressed his hopes for the immediate future: 'I just want to paint in peace . . . I want to establish the idea of myself as a painter; as an artist who uses paint. I'm not just a collagist. I've always painted. But people have forgotten this or don't know.'[16] He had produced paintings almost exclusively throughout 1963, continuing his large-scale paintings of postcards, and starting a series of paintings of pop musicians that included The Beatles, Bo Diddley (fig.35) and The Lettermen. For this latter series, he copied imagery from record covers or, in the case of *The Beatles* 1963–8 (fig.36), from a 1962 magazine picture taken just before they hit the big time. In re-presenting popular imagery, Blake could retain his Pop art allegiances whilst substantiating his position as an 'artist who uses paint'. Even the lettering is painstakingly painted rather than stuck down. Without the incorporation of collage, these works become less about a fan's iconolatry and more about the artist's aptitude for portraiture. His perfectionist draughtsmanship is expressed almost to the point of slickness,

BO DIDDLEY 1963 [35]
Acrylic on hardboard
122.6 x 78.4 (48 1/4 x 30 7/8)
Museum Ludwig, Cologne

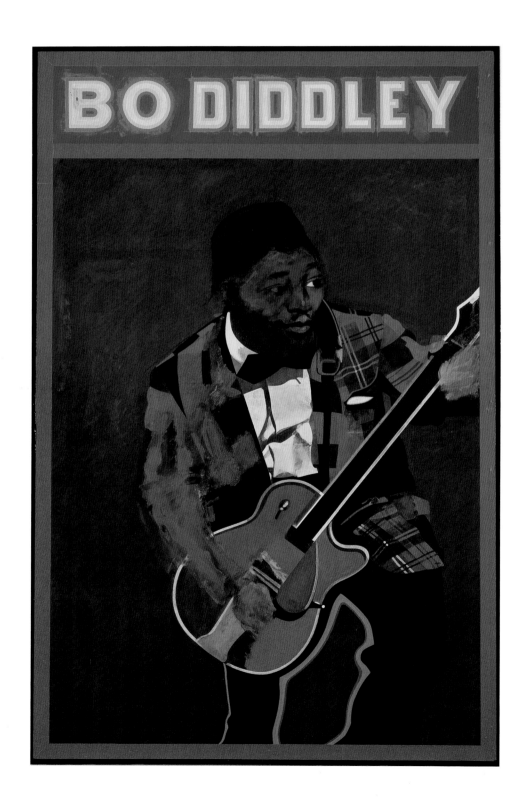

THE BEATLES 1962 1963–8 [36]
Acrylic on hardboard
121.9 x 91.4 (48 x 36)
The St John Wilson Trust

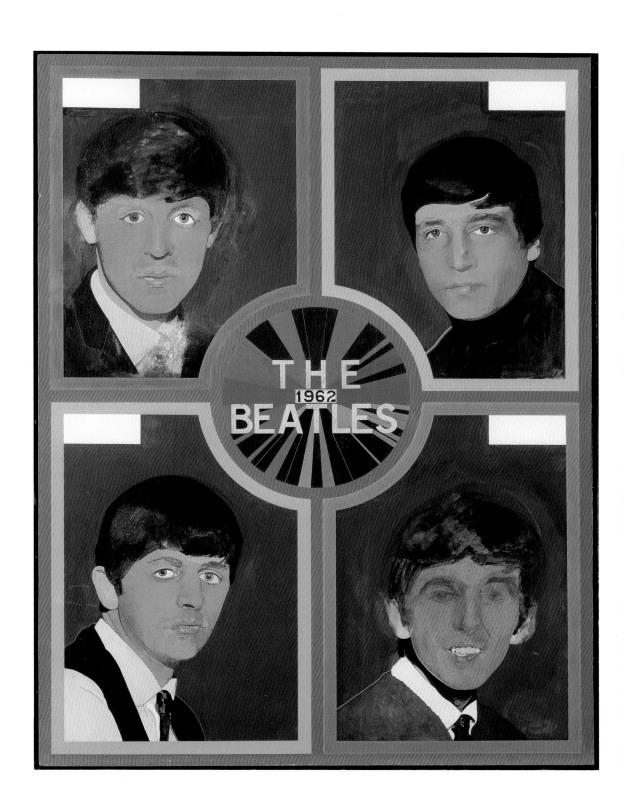

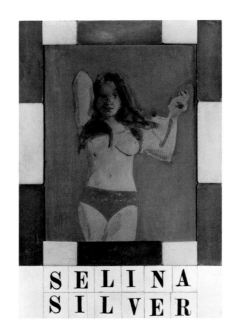

SELINA SILVER 1968–77 [37]
Oil and assemblage on panel
24.8 x 17.2 (9 3/4 x 6 3/4)
Collection of Dr Fissan

his attention to detail even embracing the imperfections of the printing process, as evidenced in the misregistered auras surrounding Bo and The Beatles.

The hard, modern quality of the musician paintings is reinforced by Blake's use of acrylic paint. Acrylic was a recent innovation and many companies were inviting artists to try out the medium in exchange for free supplies. Screen-printing was another fashionable 1960s medium, which enabled precise, colourful results, and despite his interest in painting, Blake accepted an ICA commission to contribute to a new edition of prints. He made *The Beach Boys* 1964 (fig.33), which continued the pop musician theme and recalled his trip to Los Angeles. The print effectively took his process full circle – from printed poster to painted image and back again – yet Blake was too interested in handcrafted individualism at the time to continue with the technique for long.

Always keen to safeguard against financial and creative deficiency, Blake accepted a teaching post at the Royal College of Art in 1964, and he continued to pursue various series of paintings to prevent ideas from 'drying up'. By the mid-1960s, the series of wrestling pictures that he started earlier in the decade had reached a creative peak. These wrestlers stemmed directly from his ongoing enthusiasm for this theatrical sport, and in producing them he unleashed his full narrative powers. Although based on publicity shots in sports magazines, Blake's wrestlers are, predominantly, imaginary, each with a personal history invented by the artist and conveyed by the incorporation of text, images and symbolic paraphernalia (fig.39). The resulting compartmentalised compositions hark back to his earlier fairground billboards and collage-constructions; yet, portraiture traditions are also expressed in the neutral brown ground and the conventional poses. The bulging muscles and bare flesh of the wrestlers enabled Blake to exercise his strengths in figurative painting and to communicate his awe of professional masculinity and anger. These idiosyncratic works are impossible to place: on the one hand they have a shrine-like poignancy that conveys the fragility and futility of mortal achievement, and on the other, they are humorous, down-to-earth assessments of a flamboyant sport.

Although female wrestlers featured in the series, their credibility as fighters is unconvincing (fig.38). They appear slender and immaculately groomed – hardly the types to enjoy a good catfight in the ring – and bear a close resemblance to the series of strippers on which Blake was working concurrently. Both series reveal the influence of a small number of *Pin-Up Girl* paintings that he started in 1962. He saw girlie imagery as simply another branch of popular culture to be examined. Although tiny, the *Pin-Up Girl* paintings, in their unquestioning acceptance of glamour modelling, remain his most controversial works. The critic Peter Fuller once reflected: 'Robert Melville once wrote of these, Blake "finds human warmth where others find only cliché and exploitation." This is hard to accept ... when I look at Blake's images, I experience a deadness, or veneer, in the handling – a sense of insensitivity ... too close to the callous aesthetic and personal values of the Page Three photographer.'[17] Blake was acutely aware of the antagonism many felt towards the *Pin-Up Girls*, but he continued with the stripper series nonetheless, believing, as Melville had articulated, that he could transform sleazy strip-joint scenarios into something more substantial and tender.

The strippers were all started after Blake's marriage, and perhaps for this reason they appear to express feelings of fantasy and game playing rather than frustration. They often stem from a number of

LITTLE LADY LUCK 1965 [38]
Acrylic and collage on hardboard
72.4 x 34.9 (28 ½ x 13 ¾)
Private Collection, courtesy
Waddington Galleries

MASKED ZEBRA KID 1965 [39]
Acrylic, enamel, collage and
assemblage on wood
55.2 x 26.7 x 3.8 (21 ¾ x 10 ½ x 1 ½)
Tate

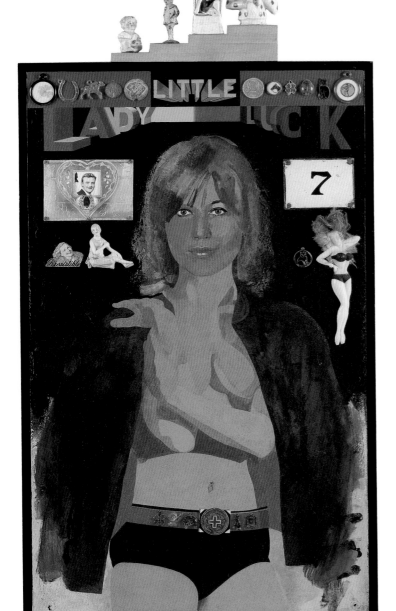

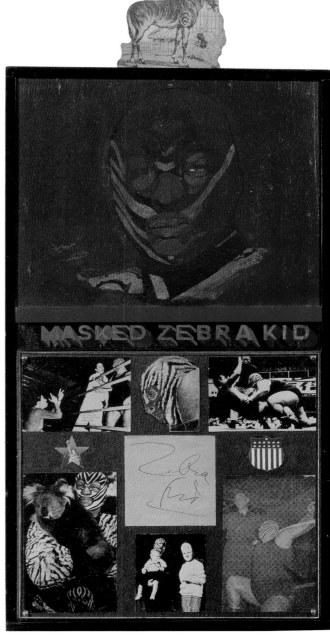

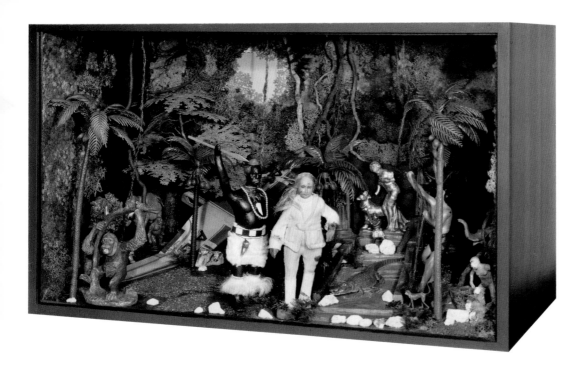

TARZAN BOX c.1965 [40]
Mixed media
36.8 x 57.1 x 30.5 (14 ½ x 22 ½ x 12)
Collection of the artist

photographic sources and mental pictures to reflect his ideal types. In *Selina Silver* 1968–77 (fig.37) Blake combines pretty, girlish features with large, womanly breasts. Letters from a child's game frame her image, adding to the sense of playful multiplicity. Like the wrestlers, the strippers are composite creations: imagined, fantastic and, in Blake's eyes, beautifully flawed. He viewed both series as celebrations of imperfection and variety; his characters occupy the fringes of society and do not conform to conventional codes of conduct. Yet, on first glance, the stereotypes inherent in these works overpower individual traits: the men are always big and strong, the women sexy and curvaceous. Blake's recognition of sexual difference extends back to his earlier interest in brother/sister, boyfriend/girlfriend, and actor/actress dichotomies. Although apparently limiting and traditional, such categories ironically provided the tidiness of mind necessary to concentrate on individual difference. Variety can exist within similarity, if we only take the time to look.

Gendered roles, whether naturally or culturally assumed, appear in another series of drawings and paintings on the theme of Tarzan. Blake started work on the subject in the mid-1960s, and his interest remains to this day. Considering his own displaced childhood, Blake's fascination with Edgar Rice Burroughs' magical tales of an aristocratic boy who gets lost in the jungle and grows up in the company of apes is hardly surprising. *Tarzan Box* 1965 (fig.40) is a rare three-dimensional work of this period and one of his favourites. It recreates, in miniature, the moment of the plane crash that leaves Jane stranded in the jungle. Most of Blake's Tarzan works, however, do not recreate specific scenes in their original context. In the same way that he had earlier interpreted set subjects such as *The Preparation for the Entry into Jerusalem*

1955–6, he adapted and relocated the Tarzan subject to fit his world. Perhaps in response to his own plans to start a family at this time, Blake became particularly interested in the relationships within the Tarzan clan. He rejuvenated the grand group portraiture of his college days to depict imaginary, often American families who assume the Tarzan family roles. *Tarzan, Jane, Boy and Cheeta* 1966–75 (fig.41) features a body-conscious family in their Santa Monica home. Made at the same time as the wrestlers and strippers, the painting shares many of their formal concerns: the tonal approach to portraiture, the meticulous observation of unblemished strongmen and strippers drawn from a range of sources, and the depiction of shelves and backboards on which symbolic accoutrements are presented. However, unlike the small-scale wrestlers and strippers, which were often made relatively quickly in response to specific exhibitions or sales, most of the Tarzan paintings took years to finish. Blake – ever the consummate perfectionist – found it difficult to feel a sense of completion; he always found areas to modify and improve, and other ideas would emerge over time that would need to be incorporated. Areas of incompletion are visible in some of his earliest college paintings, but it was only from the mid-1960s, with the security of having groups of small saleable paintings in production, that he could begin to enjoy the experience of living and working with a large canvas over time.

During the mid-1960s, Blake's parallel career as a commercial artist entered a prolific phase. *The Sunday Times Magazine* continued to commission artwork from him on a regular basis; he produced at least one cover or feature illustration in virtually every year of the decade. Unlike the Los Angeles commission of 1963, most assignments provided little choice – he would be required to illustrate the chosen celebrity or

TARZAN, JANE, BOY AND CHEETA
1966–1975 [41]
Acrylic on canvas
121.9 x 91.4 (48 x 36)
Astrup Fearnley Collection, Oslo

MONARCH OF THE GLEN 1965–8 [42]
Acrylic on canvas
121.9 × 121.9 (48 × 48)
Collection of Paul McCartney

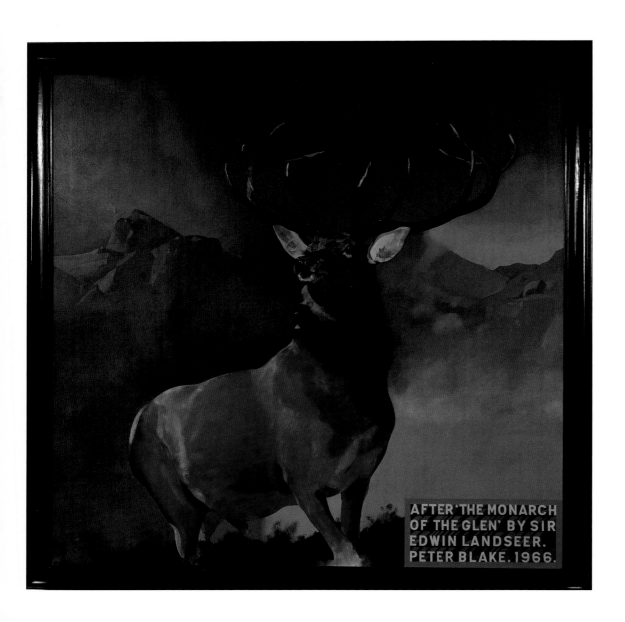

PORTRAIT OF DAVID HOCKNEY IN
A HOLLYWOOD SPANISH INTERIOR
1965 [43]
Acrylic on canvas
182.8 x 152.8 x 2.1 (72 x 60 $^1/_8$ x $^7/_8$)
Tate

theme of the accompanying feature. Portraiture seemed the most appropriate genre to use, and he quickly perfected a process of working from photographs to create small slick acrylics of people whom he would not have chosen to paint as a rule (fig.45). This conventional approach to portraiture, which involved no recourse to fiction or fantasy, could explain the flowering of the genre within his fine-art practice at this time. In 1965 he commenced portraits of Marc Boxer and artists David Hockney and Simon Rodia.

Blake enjoyed the two-way flow of ideas that existed between his fine art and commercial practices, having respect for both forms of production and refusing to belittle his graphic work by applying a different style. Graphics enabled his work to reach a wider audience. Back in the early 1960s, his main ambition as a Pop artist had been for his work to achieve 'the directness and distribution of Pop music'.[18] Yet, despite his efforts to attract non-specialist audiences with accessible subjects, his Pop works remained unique and expensive objects stuck within the exclusive gallery circuit. His commercial imagery, however, could be bought for a few pence, just like the pullout posters from which he drew such inspiration. Nevertheless, commercial work came with its own creative limitations and if Blake wanted to combine multiplicity, popularity and creative freedom, he would need to find a new approach. On the horizon was an opportunity that would enable him, not to paint pictures of the heroes of his time, but to collaborate actively with them.

Robert Fraser, a discerningly hip art dealer, had represented Blake's work since 1965, exhibiting it in numerous group and solo shows in his London gallery. Fraser was a consummate networker, and had a finger in virtually every show-business pie. In 1967 he secured an important commission for Blake to design the cover of The Beatles' *Sgt. Pepper's Lonely Hearts Club Band* album (1967). Blake had met The Beatles in the early 1960s when their fame was in its infancy, and he had struck up a particular friendship with Paul McCartney. Even before the *Sgt. Pepper's* cover was made, McCartney had commissioned the artist simply to 'paint something good'. In admiring a painting of cattle in McCartney's collection, Blake decided to make a companion piece – a technically brilliant version of Edwin Landseer's famous Victorian painting, *The Monarch of the Glen* 1851. Blake's version (fig.42) is a subtle meditation on the dispersal of art into other contexts: an image need not be limited to one artist and need not exist just the once. Landseer's original 'masterpiece' – having been plastered on a million bottles of Dewar's scotch whiskey – has become one of the most unoriginal images in the world: an irony which heightened Blake's interest in appropriating the work. The mutual respect and trust that existed between Blake and McCartney ensured a truly creative collaboration on the *Sgt. Pepper's* cover in 1967, one that enabled Blake to make his first intentionally reproducible work of art, which necessarily co-existed alongside pop music and shared its mass appeal. He was no longer copying record covers: he was creating them.

After much discussion, and with Haworth's assistance, Blake applied his full understanding of collage and sculpture to construct a surreal life-size set to be photographed for the cover. He crowded the set with a whole range of two- and three-dimensional figures and objects to create a fantastical environment that reflected the interests of all involved. The subsequent cover was unlike anything seen before in art or design. It seemed to embrace the wider spirit of late 1960s life – 'Swinging London' was a place of boundless possibility at this time, with people from many

Blake's cover design for the *Sunday Times Magazine*, 6 October 1963 [44]

Blake's cover design for the *Sunday Times Magazine*, 22 November 1964 [45]

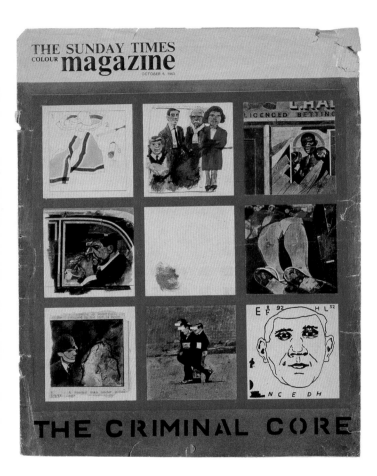

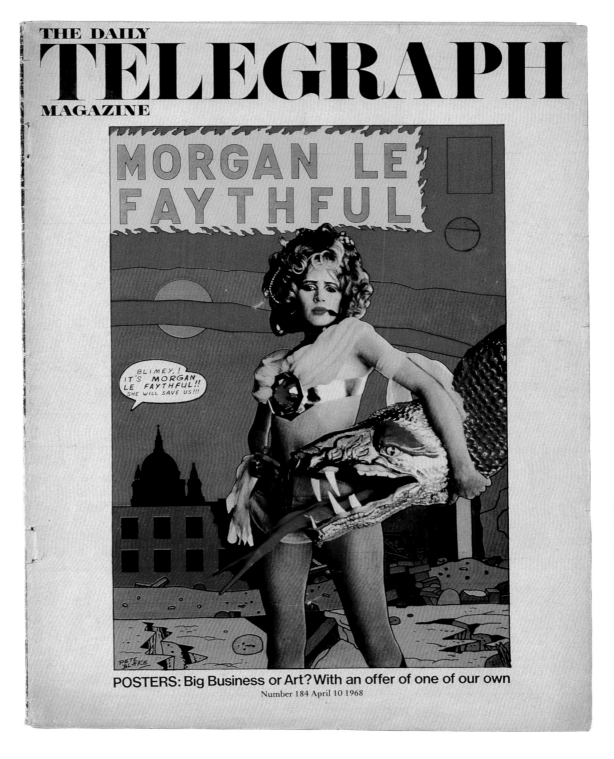

BABE RAINBOW 1968 [47]
Silkscreen on tin, edition of 10,000
66 x 44 (26 x 17 3/8)
Private Collection

backgrounds and occupations beginning to experiment with creative ways of living and working together. The *Sgt. Pepper* album has become the most enduring visual and aural embodiment of this brief yet ground-breaking moment. A full insight into the process of making the cover and its legacy today can be found on pages 54–6.

As a result of the album's success, Blake was inundated with commissions for a whole range of different projects, but he selected cautiously so as not to upset the carefully balanced elements of his practice. One project, however, was too good to miss. A London-based sign-making company called Dodo Designs commissioned him to create an image for an enamel plaque, which would be issued in an edition of 10,000 and sold for £1 each. He responded with a painting of *Babe Rainbow* 1967, a fictional, twenty-three year old wrestler from New Cross and the daughter of the 'notorious' Doktor K. Tortur (fig.76, p.91). Her features derive from a *Marie Claire* cover model, save for the broken nose that she acquired in the ring. Due to faults with the enamelling process, her image was eventually screen-printed onto tin. Four holes were then punched into the corners of each plaque to enable them to be easily mounted in people's homes. With *Babe Rainbow* Blake once more satisfied his desire to create a genuinely popular and distributable figurative art.

The *Sgt Pepper's* cover not only brought new opportunities, but also anticipated a new direction for Blake's work. Although his use of primary colours had become his trademark throughout the 1960s, for *Sgt Pepper's* he incorporated every colour of the rainbow to maximum effect. This Technicolor palette is coupled with an increasing awareness of pattern and decoration, visible in the hallucinogenic arrangement of human and floral heads. Although he did not participate in London's growing drug culture, Blake may have drawn influence from its side effect – the new multicoloured psychedelic designs that infiltrated society and lifted the greyness of the city. This subtle shift in his work is also visible in his commercial designs of the late 1960s, for which he increasingly returned to a style of paper collage more closely akin to his mid-1950s circus-act works, both in response to the demand for the cut-and-paste quality of *Sgt Pepper* and as a means of creating good results fast. He turned away from traditional portraiture to represent more otherworldly subjects, such as dreams and fairies, with obvious zeal. Although bound up in the culture and commerce of the city, many of Blake's commissions of the late 1960s expressed a new interest in a world less concrete and more ethereal. Their production anticipated an even more radical shift in his lifestyle.

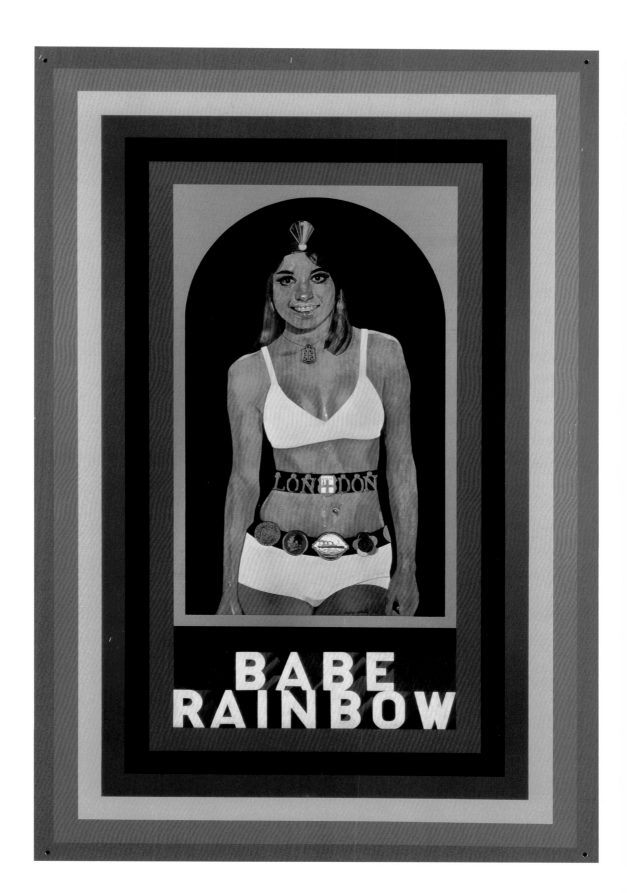

Blake's most famous work serves as a testimony to the creative dialogue that so invigorated late 1960s culture in London. The commission was not only a collaboration between art and music, but also between Blake and his first wife, Jann Haworth. Their individual reflections on their experience of making the world's most analysed album cover are expressed below.

PETER BLAKE Robert Fraser owned the gallery I was with. He was friends with many musicians and advised Paul McCartney on what art to buy. For the Sgt. Pepper's cover, The Beatles originally commissioned a cover by a design group called The Fool, who made psychedelic covers. But Robert advised Paul not to go for a psychedelic design, which in years to come would just be one of many, and suggested he commissioned an artist rather than a record-cover designer. I had first met The Beatles much earlier through a friend who used to work in Liverpool. By the time of *Sgt. Pepper's* I knew them quite well . . . To work with The Beatles at a high point in their career was great. They were very much behind me doing something interesting, and I think I knew I was making something good, but it was only as they and the record became more famous that it became something different again.

JANN HAWORTH *The cover that The Fool had done looked quite groovy and I don't think George was too happy about abandoning it. I thought it was quite fun, quite entertaining, and if you'd heard the music, which I hadn't, probably apt, in terms of the psychedelia. I don't think the final* Sgt. Pepper *cover is at all psychedelic. Neither Peter nor I had anything to do with drugs and it was very much a continuum of both his work and mine.*[19]

BLAKE As a commission it was very exciting, and it was collaborative – we talked and various things worked out. What for sure happened was that they'd worked out this concept that they were a German marching band – they wanted to step outside of being The Beatles, so ideally they thought they could go on the road anonymously as Sgt. Pepper's, but of course they couldn't. The marching band had supposedly just finished a concert, and at that point I appeared. I decided to recreate a park setting, and my other main contribution was to make a magical crowd using life-size cut outs and waxworks. It was the

kind of crowd that you could never bring together. I asked each member to provide a list of people to be included. Paul McCartney and John Lennon each gave long lists. George Harrison only gave a list of about six Indian gurus, and Ringo went along with the other chaps. Jann, Robert Fraser and I also made suggestions. It took two weeks to build the set in Michael Cooper's studio, and in the evenings we would go to Abbey Road to listen to the progress of the album. Everyone was around, and there was Robert Fraser, and lots of joints being smoked; it was a very, very hippy-dippy experience!

HAWORTH *Paul played us the tape of* Sgt. Pepper, *which was still being worked on, and Peter thought the idea of making a Lonely Hearts Club would be interesting, a group of people with the Beatles in front. Early in the sixties Peter had done some things, cutting out Victoria heads, engraving, sticking them down, then doing a circus act in front of that ... The part that's very much my own was that I always hated lettering on things. I loved the idea that lettering could be an integral part, and I was into fairground lettering at the time. So I thought it would be nice to have a real object with lettering on it, instead of lettering the cover. So I thought about the drum, then about the civic lettering that was around at that time ... The other part I felt very strongly about was that when you went from the front, you wanted to have that connecting point of 3-D things that bled into the 2-D things, as we were not doing it as artwork. This bothered Peter a lot later on, because it was so retouched, so messed about, the photograph, it ended up looking like artwork, a collage done on paper rather than a set that was built. Madame Tussaud's were very generous, lending us some figures, and then the Beatles were going to be in front of the crowd, and I put some of my figures in, and that blended the 3-D world into the 2-D world.*[20]

BLAKE Although I had been commissioned to do the cover, Jann had a big input and the use of her actual figures was important. Looking back I wonder how much of an influence I was on her and in turn she was on me, because the first work I saw by her was at the ICA and she had made a room, by which point I had already made my works with doors and windows, but then I did things later that were probably influenced by the rooms. It was almost a kind of leapfrogging of influences.

There have been so many pastiches of the cover since it was released. I started to collect them and I got to about twenty and then I just gave up – I would be sent one a week at one point. I suppose the most famous is the Frank Zappa one, where they used terrible old models and rotten vegetables and stuff [fig.48]. Although it's very funny now, at the time I was upset because it's easy to parody but not so easy to invent! I have never had any rights to the cover because Robert Fraser sub-contracted me to do it. He paid Jann and me £200, which didn't really cover the amount of work involved. Even the people that did the flowers were paid more! So it wasn't fair at the time and I suppose I would have liked some further recognition. Today I've lost a lot of the bitterness I once felt about the cover – I suppose that comes from my 'retirement'. Mostly it's frustrating that people think that's all I've done. But it's also very useful when people say 'What do you do?'

Cal Schenkel's spoof cover design for the Mothers of Invention's album *We're Only In It For The Money*, 1968 [48]

Blake's 1967 cover design for The Beatles' album
Sgt. Pepper's Lonely Hearts Club Band [49]

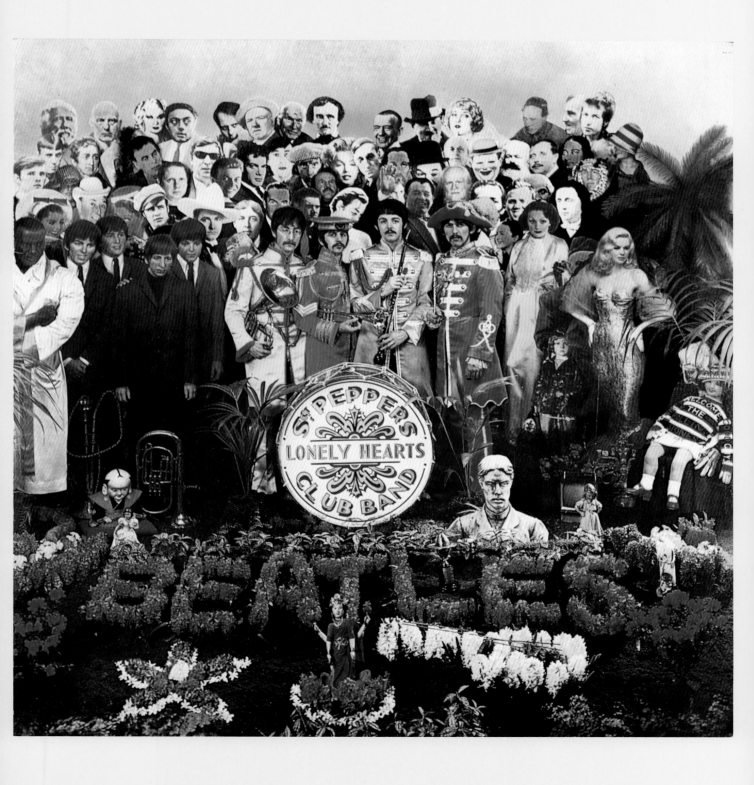

PUCK, PEASEBLOSSOM, COBWEB,
MOTH AND MUSTARDSEED
1969–84 [50]
Acrylic on hardboard
99 x 76.2 (39 x 30)
Galerie Claude Bernard, Paris

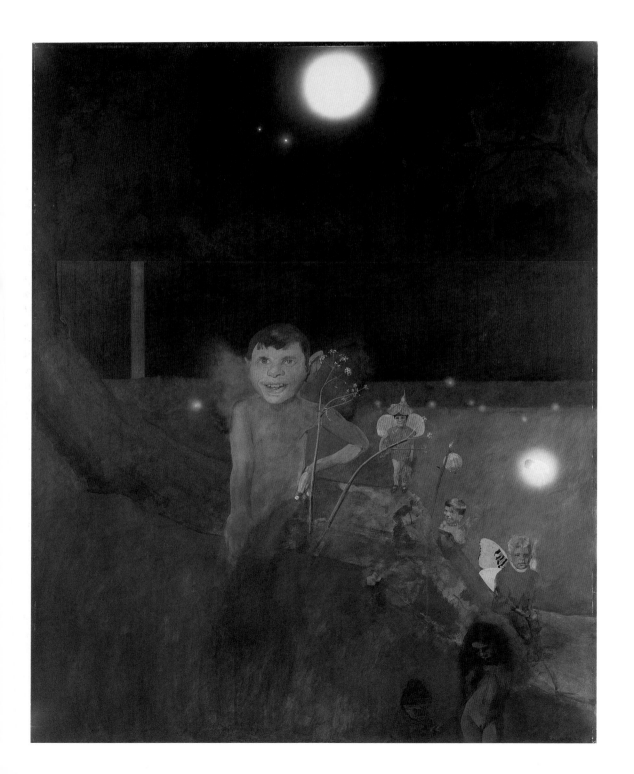

4

In November 1968, Jann gave birth to a daughter, Juliet Liberty. The naturally joyful experience made an immediate and significant impact on Blake's work. His paintings of 1968–9 conjoin his renewed interest in childhood with the decorative exuberance of his new rainbow palette. *Girl in a Poppy Field* 1968–9 (fig.52) started as an impromptu swatch of rectilinear patterning to test a new box of watercolours, but developed into a blaze of decoration and a celebration of blossoming girlhood. For *A Mad Tea Party at Watts Tower* c.1968–92 (fig.51) Blake transported a scene from Lewis Carroll's *Alice in Wonderland* to the Watts Towers to justify the cheery crowd of colour behind the characters.

Blake's interest in Carroll derived from the influence of a new friend, the artist Graham Ovenden, whom Blake had previously taught. Ovenden was an expert in Victorian culture and introduced Blake to the extraordinary vision of the Victorian imagination. Blake, who had himself attempted to unite reality and myth in his work, became fascinated by the Victorian belief in fairies as expressed in the genre of fairy painting championed by artists such as Joseph Noel Paton and Richard Dadd. He started to collect fairy-tales, both to build up a library for Liberty, and out of admiration for the work of illustrators such as Arthur Rackham and Maxfield Parrish. Their belief that fairies and children shared an enchanting naivety was expressed in their childlike representations of the supernatural. Blake started a number of fairy paintings and drawings in 1969, turning, as had many of his Victorian forbears, to Shakespeare's *A Midsummer Night's Dream* for inspiration. *Puck, Peaseblossom, Cobweb, Moth and Mustardseed* 1969–83 (fig.50) is the most ambitious painting of this group. It expresses Blake's close allegiance to Victorian ideology and technique whilst retaining a connection with popular

culture: he blesses Puck with the features of pop star Del Shannon, indicating that a belief in fairies is only as wistful as the worship of celebrities.

Blake's works of 1968–9 not only construct an idealised vision of eternal childhood, but also present an idyllic view of the countryside, one quite distinct from his wartime experience of rural life. They indicate a yearning for a quieter existence, a place to bring up his daughter, a rural Shangri-la. Both he and Haworth were in agreement: London life had lost its lustre. Within the space of a year it had turned from a place of intense creativity to one of silly cliché and cynical marketing. He was tired of the excessive publicity that accompanied his modest fame, the steady stream of photo shoots and interviews for inane features on the decor of his bathroom or the shoes on his feet. Many of his contemporaries, including the painters Howard Hodgkin, Richard Smith and Joe Tilson, shared his frustrations and were planning their exodus to – quite literally – pastures new. The need for change was in the air. It was time to leave the city.

In November 1969, Blake and his family moved to a converted railway station in Wellow, Avon. Many in the art world were surprised at this urban artist's desire for rural solitude, but for Blake the move was as much about getting back to the basics of his profession as it was a retreat. He arrived in Wellow with the sparse kit of a Sunday painter (pencils, watercolours and the occasional use of oil) and with the increasing belief that his practice was essentially traditional: 'having done all sorts of things with picture making, I am now very happy just to get back to a rectangular painting on canvas with brushes and paint and very simple old-fashioned subjects . . . I have gone back to something which is more or less academic.'[21] Ironically, he viewed the notion of being intentionally

A MAD TEA PARTY AT WATTS TOWER
1968 and 1992 [51]
Oil on canvas
91 x 122 (35 7/8 x 48)
Galerie Claude Bernard, Paris

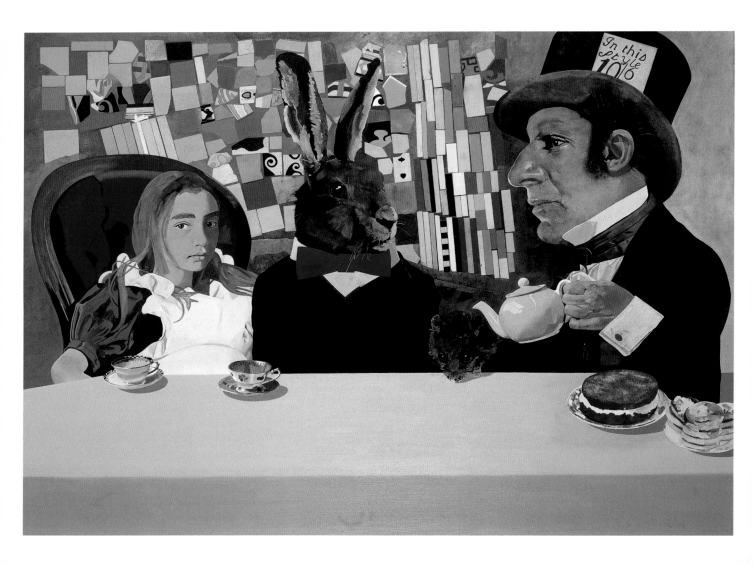

GIRL IN A POPPY FIELD 1974 [52]
Based on a watercolour of 1968–9
Screenprint on paper
41.3 x 27.3 (16 1/4 x 10 3/4)
Tate

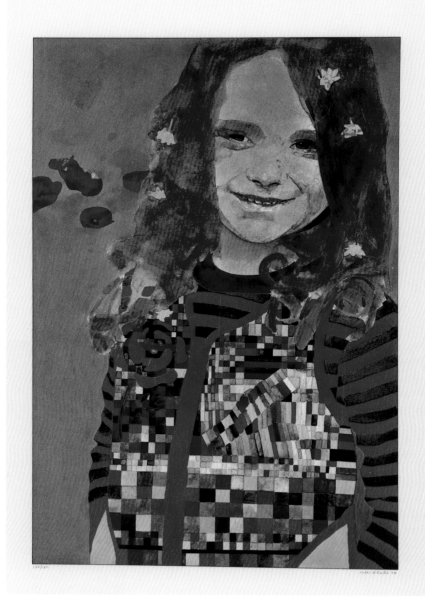

behind rather than ahead of art trends as a new trend in itself: 'People are so busy *not* doing the traditional art subject ... I am now doing them and, suddenly, its extraordinary, one's broken down a new barrier.'[22] In being about a hundred years out of date, his 'new' approach was a playful gibe at the art world's obsession with advancement.

Blake's first years in Wellow were idyllic. He devoted his time to family life and to the development of the house and garden. Although his output decreased in scale and quantity, the watercolours and drawings that he did produce express a rare poignancy and delicacy and exude a sense of open space: 'My work started to lose that urban toughness.' One of his first projects in Wellow was to illustrate Lewis Carroll's *Through the Looking Glass* (1970–1) for a commission he had accepted in the late 1960s. The eight resulting watercolours (figs.65, pp.74–7) were widely acclaimed; the art critic William Feaver praised their 'frail magic' and the way in which Blake 'teases and trickles each wash over the crisp snowy paper, edging each tonal value into place'.[23] At about this time, the centrality of Liberty in Blake's world became a recurrent subject. In *Liberty Blake in a Kimono* 1971 (fig.53), she assumes a full-frontal pose and stands before a flat green background, just like the children in his paintings of the 1950s. Yet, unlike her precedents, Liberty presents nothing but flowers. She has no need to justify her existence, and her image is not haunted by Blake's visions of how childhood could or should be. A similar purity infuses the precious little paintings of flowers in vases which Blake made at this time. In painting the posies that Liberty had picked for friends or relatives, Blake expressed his acute joy in witnessing her increasing development of thought and action. Flowers in bloom symbolise the passing of time and human transience, and, in capturing the

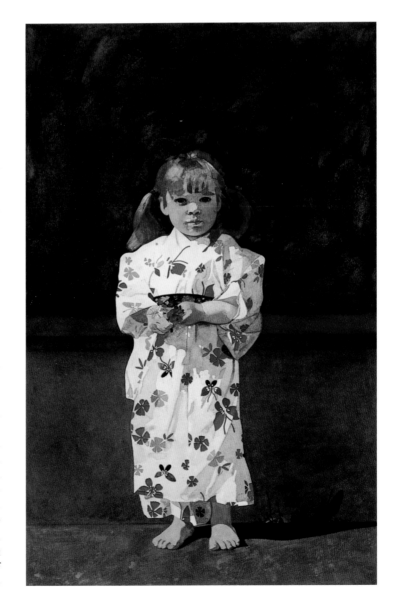

GIRL FROM THE ISLAND OF BALI,
pl.113 from *Nature and Culture* series
1973–7 [54]
Pencil drawing
58.4 x 45.7 (23 x 18)
Private Collection, courtesy
Waddington Galleries

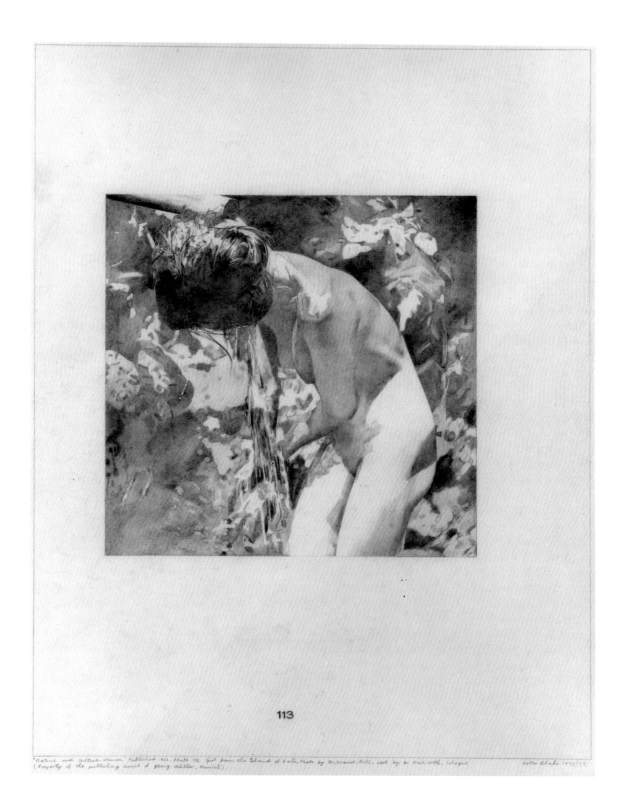

113

The Brotherhood of Ruralists.
From left to right, front: Peter Blake,
Liberty Blake, Jann Haworth,
Graham Ovenden, Emily Alice
Ovenden, Annie Ovenden, Graham
Arnold; back: David Inshaw, Daisy
Blake, Anne Arnold, Edmund Dante
Ovenden [55]

posy in paint, he consciously sought to preserve such moments for as long as possible.

As the initial excitement of being in the countryside subsided, Blake began to search for new inspiration. Finding little stimulation in the landscape – the 'cow shit and flies'[24] forced him to abandon *plein-air* painting almost immediately – he began to look beyond the boundaries of the village. In 1972 he returned to a favourite urban subject: wrestling. He made five watercolours, each featuring an imaginary wrestler from a different nation (fig.74, p.89). This emphasis on racial characteristics extends his earlier use of types to celebrate difference. Rekindling his interest in the female form, he made five technically brilliant pencil drawings based on photographs of international female 'types' taken from *Nature and Culture* by Dr Peter Landow – the kind of tome used for pornographic as well as anthropological appreciation (fig.54). Blake's interest in people from distant lands at first seems surprising considering his location in what was a predominantly white area of Britain. Yet, on reflection, his growing view of himself as an urbanist stuck in a rural community renders his newfound interest in foreignness understandable.

Life in the country divorced Blake from his stimulating social circle. As a way of keeping in touch, he invented a series of *Souvenirs* – small-scale collages or simple constructions each made to appeal to the individual recipient (fig.56). In the summer of 1974 he and Haworth were offered an exhibition at the Festival Gallery in Bath, and he responded by making thirty such *Souvenirs*. One celebrates the birth of his second daughter, Daisy, but most are dedicated to absent friends. To make the *Souvenirs* he chose from his standard vocabulary of earlier inventions – the noticeboard covered in postcards, the use of collage, the assimilation of another artist's style – and he

incorporated images and objects that expressed shared memories or personal tastes. But the significance of these works is not so much the resourceful simplification of his existing oeuvre as it is the desire to communicate. Blake took pleasure in both the act of giving to his friends and the knowledge that he would remain in their thoughts and not be forgotten.

The solution to Blake's isolation emerged later in 1974, during preparations for an exhibition at the Festival Gallery for which he was the selector. The process of inviting artists to contribute enabled him to build up a new social circle. He developed an admiration for the work of David Inshaw and, through visiting him in Devizes, met Graham and Ann Arnold, who had also escaped city life to pursue their interest in the British landscape. Blake immediately saw the parallels with his own situation and that of Graham Ovenden and his wife, Annie, who had recently moved to Cornwall. To make the connections, Blake and Haworth invited everyone to dinner on 21 March 1975. After much merriment, the seven artists stumbled across the idea of forming a collective. Someone suggested the name 'The Brotherhood of Ruralists', which, although deemed rather pompous by some, rang so true that it stuck. 'Brotherhood' implied supportive friendship and also referenced their admiration for the nineteenth-century Pre-Raphaelite Brotherhood – a group of seven British artists who had expressed a similar feeling for nature, realism and the past. The term 'ruralist' – they discovered from the dictionary – applies to a person who leaves the city for the country, describing them perfectly (fig.55).

Ruralist objectives were agreed enthusiastically at the very first meeting. Although no formal manifesto was ever released, Blake's summary of Ruralist values in a statement of 1978 comes pretty close:

SOUVENIR FOR GILBERT & GEORGE
1974 [56]
Collage
45.1 × 24.7 (17 3/4 × 9 3/4)
Collection of the artist

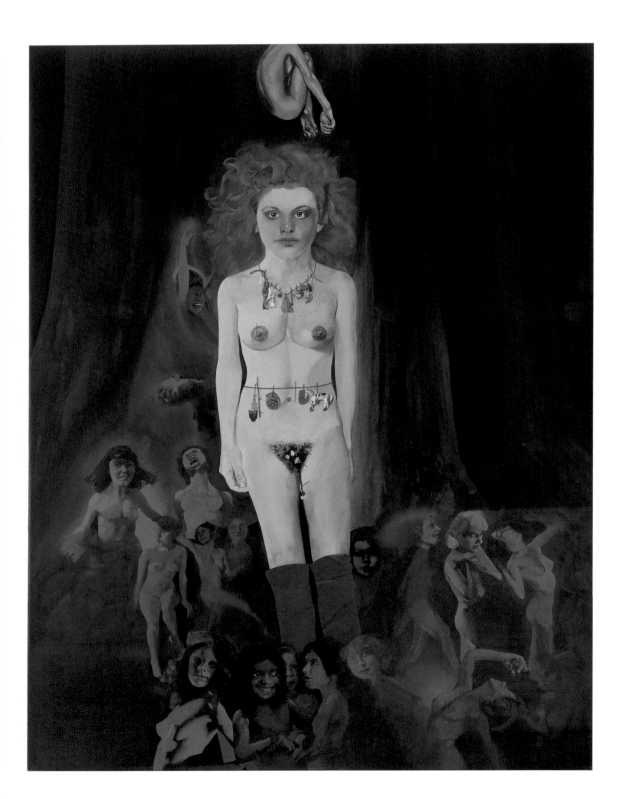

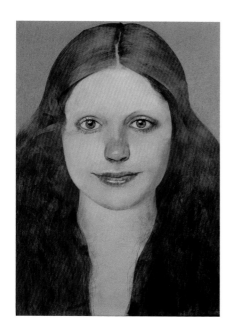

TITANIA 1972–4 [58]
Oil on board
17.8 x 11.8 (7 x 4 ⁵/₈)
Private Collection

Simply, our aims are the continuation of a certain kind of English painting; we admire Samuel Palmer, Stanley Spencer, Thomas Hardy, Elgar, cricket, English Landscape, the Pre-Raphaelites, etc . . . Our aims are to paint about love, beauty, joy, sentiment and magic. We still believe in painting with oil paint on canvas, putting the picture in a frame and, hopefully, that someone will like it, buy it and hang it on their wall to enjoy it.[25]

The unquestionable admiration of such unfashionable traditions reflected the group's unanimous frustration with contemporary practice and criticism, which they believed to be more concerned with political agendas than art pleasures. The Ruralists, delighted to have found such like-mindedness, decided to meet four times a year with the turn of the seasons, and to take an annual working holiday to Coombe, Cornwall where they would draw, exchange ideas and enjoy each others' company.

The rush of Ruralist plans for collaborations and group exhibitions put the purpose back into Blake's life. The sense of camaraderie gave him the confidence to pursue the more visionary elements of his practice. In 1976 he started a major oil painting of Titania, the queen of the fairies in *A Midsummer Night's Dream*. Prior to this, he had made various small versions of Titania in oil or watercolour. The *Titania* of 1972–4 (fig.58) assumes one of Blake's favourite portrait compositions – face only, full frontal, big eyes, and luscious bee-stung lips – painted with a realism and translucence reminiscent of Hans Holbein or early Lucian Freud: each hair, each eyelash beautifully present. But whereas this earlier *Titania* could represent any pretty girl, the full-length fairy in his 1976 version is expressed with a great degree of imagination and fantasy (fig.57). To Blake, Titania is about half the size of a human and has none of our inhibitions – she decorates her naked body innocently, using nature as her wardrobe. *Titania* marks a new model in Blake's canon of fairy painting; she does not embody the childlike asexuality of his earlier fairies. Like the nymphs in classical mythology and Blake's urban strippers, she is a figment of male fantasy, poised eternally between innocence and desire, childhood and womanhood, apparently available yet essentially out of reach.

Like the large canvases started in the mid-1960s, *Titania* took years to complete and underwent a myriad of transformations. Alongside her creation, Blake commenced a series of 'bread and butter' fairies. Although – like the wrestlers and strippers – the fairies had a moneymaking responsibility, he painted them with his characteristic care, affection and imagination. Exquisite and jewel-like, each tiny painting features the head of a single fairy whose history and qualities were invented to suit a decorative picture frame selected by the artist from his collection. By working in this way, Blake was consciously attempting to revive the appreciation of frames, which had been increasingly sidelined in contemporary practice. The fairy series comprised two main types: the cute elfin innocent and the sexy girl-woman typified in *Flora – Fairy Child* 1977 (fig.59). *Flora* derives from a magazine picture of a model called Florence, yet she is encased in an elaborate Italianate frame to reflect her supposed Roman ancestry, confusing boundaries of past and present. The interest in naive sexuality had a definite presence in the films, books and art of this time. Graham Ovenden was making controversial paintings of naked children, and Vladimir Nabakov's novel *Lolita* (1959) was still fresh in the public imagination. Although Blake never painted children in a sexual way, his hybridised girl-women of the late 1970s

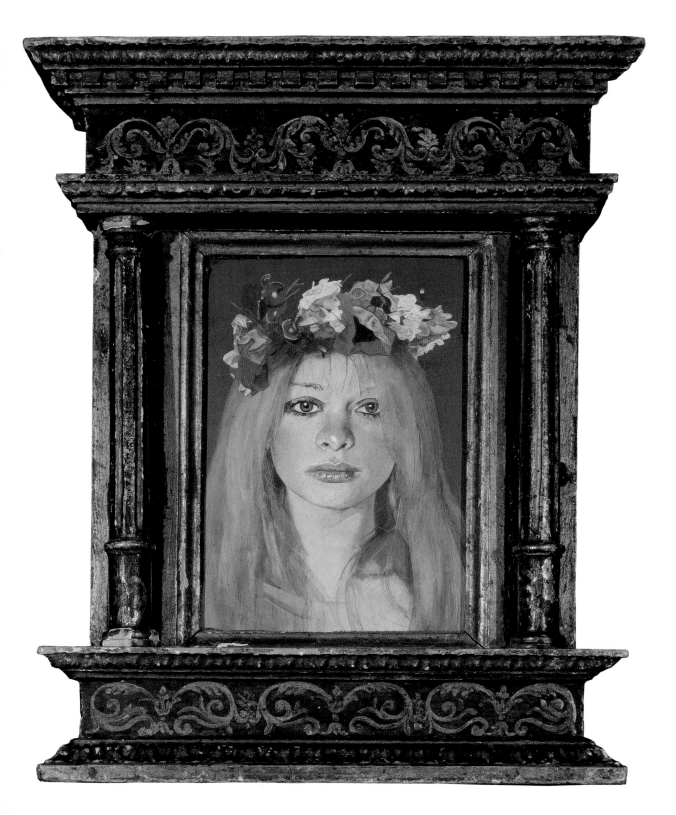

HOLLYWOOD BLONDES VERSUS
THE GILDED SLUTS 1977 [60]
Watercolour
13.7 x 46.4 (5 3/8 x 18 1/4)
Private Collection

almost subconsciously absorb Nabakov's complex view of pubescence as a mixture of 'tender dreamy childishness and a kind of eerie vulgarity, stemming from the snub-nosed cuteness of ads and magazine pictures, from the blurry pinkness of adolescent maid servants in the Old Country'.[26]

The Ruralists first exhibited together in the Royal Academy Summer Exhibition of 1976, which Blake, as an associate member of the Academy since 1974, had helped to select. The critical response was mixed, with many critics accusing the Ruralists of self-satisfied exclusivity and a regressive, mawkish conservatism. Blake continued to show work individually, and in 1977 he staged an innovative mini-retrospective exhibition, *Souvenirs and Samples*, at Waddington Galleries – which has represented his work ever since his move to Wellow. This exhibition was the first to reveal his categorical and quirky curatorial concepts. He presented a number of his *Souvenirs* alongside five examples from each area of his oeuvre to date, and the works were hung close to the ground to allow them to be appreciated by children. He included his recent fairies and Ruralist watercolours, but he also showcased a whole range of new wrestlers, including a series of gay tag teams with titles as flamboyantly bawdy as *Hollywood Blondes versus the Gilded Sluts* 1977 (fig.60). The exhibition expressed Blake's renewed confidence in all facets of his practice, whether rural or urban in origin.

The success of *Souvenirs and Samples* was overshadowed by the harsh attacks Blake received for his contribution to the *Hayward Annual '77* show just a month later. His 'five works in progress' extended the *Souvenirs and Samples* concept, including the paintings of Hockney, Tarzan and Titania. His decision to exhibit unfinished work arose from his growing belief that by showing paintings at various stages of development, he could reveal the narrative and life of the paint to the public. But the broadsheet critics took a different view, perceiving Blake's paintings to be unresolved and whimsical – 'sketchy', 'soggy', 'boring', 'dismal'. They also chose the moment to reaffirm their contempt for Ruralism by mocking *Titania*, questioning Blake's motives for titivating her body in such a salacious manner. Not one to accept bad press lightly, he interpreted their response as a personal attack devoid of constructive criticism and with little appreciation for art made outside of their interests. In an open letter to *The Guardian*, he accused British art critics of intentionally destroying artists and of wasting too much space on art politics: 'I wish you would look at the work and review it'.[27] His letter, albeit verging on the paranoid, sparked a lively debate that simmered well into 1978, with support on both sides. Although pleased to have made his point and to have facilitated a discussion, he was desperate to return to his work.

Ruralism continued with increasing vigour despite the critical slamming. 1978 saw the BBC broadcast of John Read's idyllic film, *Summer With The Ruralists*, which followed the lives of the artists whilst on their annual holiday in Cornwall. Although mocked by many urban critics, the film brought the work of the Ruralists to the favourable attention of the wider public. In the same year, the group was invited by Arden Shakespeare to share cover illustrations for a new set of the complete Shakespeare plays. Book illustration commissions for Blake had also increased as a result of the continuing literary bent of his paintings, and by the end of the decade such commissions formed the major part of his commercial income. He proved himself to be a sympathetic and flexible practitioner, able to respond

Blake's illustration for Roger
McGough's *Summer with Monika* [61]

John Everett Millais
OPHELIA 1851–2 [62]
Oil on canvas
76.2 x 111.8 (30 x 44)
Tate

to a given text accurately, yet with a certain magic. He achieved particular success with his illustrations of Roger McGough's celebrated poem *Summer with Monika* (1978, fig.61), which included hatched pen drawings so fine they look like wood engravings. His interest in the printing process and in traditional techniques, prompted *Side Show* 1978 – a series of five intricate wood engravings based on unusual people from the circus.

Despite Blake's constant desire to extend his artistic vocabulary, figurative painting remained the central concern of the Ruralists, and in the late 1970s they agreed to produce work on a theme of Ophelia for a future exhibition at Trinity College, Cambridge, where David Inshaw had been Artist in Residence since 1975. Ophelia, the tragic heroine of Shakespeare's *Hamlet*, slowly grew insane and eventually drowned after being denied Hamlet's love. The death of Ophelia was a mainstay in Victorian painting and, with reference to John Everett Millais (fig.62) and Arthur Hughes, Blake depicted the moment when she gets caught up in the river, still clutching the twigs she believed to be flowers: 'There's rosemary, that's for remembrance; pray, love, remember: and there is pansies, that's for thoughts'.[28] Despite remaining ever young in collective memory, Ophelia shares none of Titania's spirited immortality. She is all too human, and Blake's interpretation of her remains one of his most melancholic and haunting paintings to date (fig.63). It comes as no surprise to learn that this painting was developed at a time of increasing tension within the family home. In the summer of 1979 Blake's rural experience came to a sudden and irrevocable end: Haworth had met someone else. The marriage was over. He had little choice but to return to London alone, save for a clutch of memories and thoughts.

OPHELIA 1977 and 1983 [63]
Oil on hardboard
139.1 x 96.8 (54 3/4 x 38 1/8)
Claude Bernard Gallery Ltd,
New York
(Also see fig.78, p.93)

Blake's acclaimed illustrations of Lewis Carroll's famous narrative *Through the Looking Glass* (1872) mark a highpoint in his countryside oeuvre and his contribution to book illustration. Here we discuss the story behind their making.

NATALIE RUDD What first attracted you to this subject?

PETER BLAKE I wouldn't have read Lewis Carroll as a child. I probably became interested after meeting Graham Ovenden, whom I taught at the Royal College in the late 1960s. He was making paintings of young girls and was certainly very interested in Alice. I found in Alice the same kind of magic that everyone does. But I was especially interested in its dreamlike quality, its magical realism, and in that sense of living one's life through other characters – something I've often done in my work. Whoever Alice is following she's looking for something – maybe she's searching for whatever the reason for living is . . . In becoming interested, I started to collect Alice books and objects. I also started pictures like *A Mad Tea Party at Watts Towers* [1968–92], which, in a way extends the magic in my terms – I'd done pictures about the Watts Towers in LA and the idea of the tea party taking place there is about using the magic and putting it somewhere else.

NR Your response to *Through the Looking Glass* is more literal. How did this series arise?

PB A publisher invited Graham and me to illustrate one book each: he did *Wonderland* and I did *Looking Glass*. The idea originally was to make a pair of books but at the time there was a print strike and so they couldn't afford to produce books, so we did them as prints instead.

NR The original Carroll text features fifty engravings by the Victorian illustrator, John Tenniel. How did you select just eight?

PB I had to follow the mechanics of making a book – the publisher probably said eight was the ideal number. I then picked up on the characters that I liked. I wanted Alice to appear in every image, and I especially like Tweedledum and Tweedledee and Humpty Dumpty. I love the White Knight – he's probably my favourite character – such a dotty old man!

NR How did you respond to such esteemed originals?

PB The Tenniels are so definitive. Nobody can illustrate Alice without them and nobody can ever better them. All you can really do is make tiny variations – and you cling onto these things – like in mine where the price tag in Hatta's hat says 'five shillings' rather than the original '10/6'. But there are other changes: I don't think he ever did a portrait of Alice; and using watercolour was another way of doing something different.

NR Unlike your earlier representations of childhood, you worked very closely from photographs to make these works.

PB Yes I took photographs of the children of a friend of mine, Peter Gatacre, who is half Dutch and lived in Holland some of the time. His daughter Amelia played Alice [fig.64]. I hired her costume from Bermans' and took it to Holland. Amelia was very like Alice – calm and quiet, and she was a tremendous actress. I would read passages to her and say, 'You're coming through the wood and can hear soldiers coming!' and she'd get very

Amelia Gatacre as 'Alice'
[64]

ILLUSTRATIONS TO 'THROUGH THE
LOOKING GLASS' 1970 [65]
Eight screenprints on paper
Each 24.1 x 17.8 (9 ½ x 7)
Tate

involved. Sometimes Will, her brother, would be in the picture with her and would play different characters. Their younger sister Sophie became Tweedledum or Tweedledee. I later discovered she was horrified; she always wanted to be Alice!

NR How exactly did you work from the photographs?

PB These are some of the first, where I would have traced them. I would literally have traced the photographs and then drawn through the tracing, so there's a line that appears through the watercolour occasionally. I had used watercolour since Gravesend, but it was around this time that I started to use it a lot. Watercolour is a fast medium: it dries instantly. It's also a very easy technique; you get very good effects and I love using it. With Alice, if I started one and worked straight through, it would have taken about a month, I'm guessing.

NR Do the landscape backdrops derive from Holland?

PB Some do. I photographed the children in their garden, which was laid out like *Alice in Wonder-land*, and so there was a wood, and a garden based on the talking flowers. But others, such as Queen Alice and Humpty Dumpty, have a kind of Somerset landscape – I started the series when I was still living in London, but the main body was made after moving to Wellow.

NR Although the Brotherhood of Ruralists wasn't officially formed until 1975, were you living the ruralist life at this stage?

Only in the literal sense – a ruralist is someone who moves from the city to the country, so in

those terms, I was a ruralist because that's what I'd done. Although, looking back, the Alice watercolours were about as close as I got to Ruralism, and the fairy pictures came out of them. But I think in a curious way the fairy pictures are far more knowing than the Alice pictures. The fairies again come back to being part of my travelling company – they could just as easily be strippers. They look urban.

NR Your interest in Alice developed into various ambitious and collaborative projects.

PB Yes. Graham Ovenden and I managed to persuade Leslie Waddington to put on a themed show of Alice work and collectables [1970]. Jann and I designed a whole garden based around Alice for our house in Wellow – it was one of those things that got started and never finished. Then later, with Graham, we were going to build a chapel to Lewis Carroll. I got some stained glass made from the Alice prints, but again it didn't ever happen – the glass is now displayed in my house. There was also the Looking-Glass School, which Jann set up in 1973, mostly because Liberty was having a bad time at the village school. Property was very cheap and she set it up in a barn. The kids would take in a picnic and have their lessons in the meadows: it was idyllic and rather wonderful but, like everything, things change.

and to show you I'm not proud, you may shake hands with me!" A/P Peter Blake

and the two knights sat and looked at each other for some time without speaking. A/P Peter Blake

AND TO SHOW YOU I'M NOT PROUD, YOU MAY SHAKE
HANDS WITH ME!

AND THE TWO KNIGHTS SAT AND LOOKED AT EACH
OTHER FOR SOME TIME WITHOUT SPEAKING

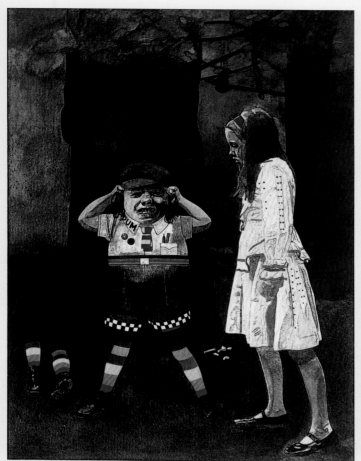

'but it isn't old!' Tweedledum cried, in a greater fury than ever. 'It's new, I tell you — I bought it yesterday — my nice NEW RATTLE!' and his voice rose to a perfect scream. A/P Peter Blake

'It isn't manners for us to begin, you know,' said the Rose. A/P Peter Blake

'BUT ISN'T IT OLD!' TWEEDLEDUM CRIED

'IT ISN'T MANNERS FOR US TO BEGIN, YOU KNOW',
SAID THE ROSE

"For instance, now, there's the King's Messenger. He's in prison now, being punished! and the trial doesn't even begin till next Wednesday: and of course the crime comes last of all." A/P

Peter Blake

Just at this moment, somehow or other, they began to run. A/P

Peter Blake

FOR INSTANCE NOW, THERE'S THE KING'S MESSENGER

JUST AT THIS MOMENT, SOMEHOW OR OTHER,
THEY BEGAN TO RUN

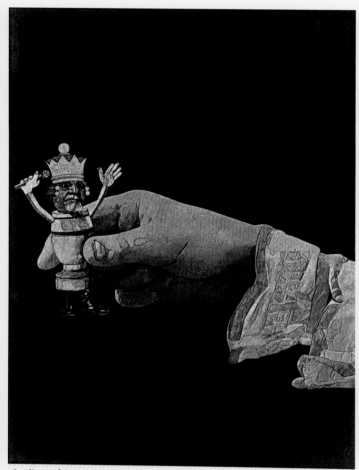

So Alice picked him up very gently. A/r Peter Blake

'Well, this is grand!' said Alice. 'I never expected I should be a Queen so soon.' A/r Peter Blake

SO ALICE PICKED HIM UP VERY GENTLY 'WELL, THIS IS GRAND!' SAID ALICE

'THE MEETING' or
'HAVE A NICE DAY, MR HOCKNEY'
1981–3 [66]
Oil on canvas
97.8 x 123.8 (38 ½ x 48 ¾)
Tate

RE-ESTABLISHMENT

The collapse of Blake's marriage made a devastating impact on his life. Circumstances surrounding the split were bitter and his despair was worsened by the fact that his beloved daughters remained in Wellow with Jann. Blake had reached his lowest ebb; even being back in the throb of London did nothing to raise his spirits. He suffered a short but intense nervous breakdown and found life, let alone work, difficult to contemplate.

A breakthrough in Blake's recovery emerged in November 1979 with an invitation to the opening of an exhibition featuring his work at the L.A. Louver Gallery, Los Angeles. His immediate reaction was to decline the offer – family life had restricted unnecessary travelling – but he soon realised there was nothing stopping him. After much deliberation, he decided to travel with the painter Howard Hodgkin, whose work was also represented in the exhibition and who had just separated from his wife. They arranged to stay with their old friend David Hockney. From the outset, the trip was a hedonistic affair – a chance to block out the bitterness with copious amounts of alcohol, parties and bonhomie. During the daytime, Blake reacquainted himself with the sharp light and the exotic characters of Los Angeles that had so inspired him in 1963, responding with a number of sketches of the habitués of Venice Beach. On the plane home, Blake and Hodgkin reflected on how Los Angeles had revitalised their zest for life and made them aware that personal and artistic recovery was possible. To mark their life-changing experience, Blake suggested they paint three pictures each and exhibit them in an LA-style gallery with sand on the floor. Howard agreed wholeheartedly, and Blake decided the content of his paintings before the plane touched down.

Back in London, Blake set about the task of rebuilding his life. He resolved not to wallow in self-pity, remarking in his entry for *Who's Who* at this time that 'living well is the best revenge'. Although starting a new relationship was the very last thing on his mind, in the summer of 1980 he was reacquainted with the artist Chrissy Wilson, whom he had met some years earlier through a friend. The attraction was instant and mutual: within months they had bought a house together in Chiswick. Soon after, Blake's professional life received a much-needed boost. In early 1981 he was approached by the Tate to stage a major retrospective of his work two years hence. Blake was delighted and honoured, and immediately embarked upon a period of intense production, working from his new studio at home. He was back on track.

One of Blake's first aims was to realise the three Los Angeles paintings so that he could present them alongside Hodgkin's in a specially decorated room at the Tate. The smallest of the trilogy is an oval portrait depicting the actor Montgomery Clift, whose autobiography Blake had read during the 1979 trip. Far more ambitious, however, are the two paintings in which Venice Beach becomes a stage for his memories and ideas. *'The Meeting' or 'Have a Nice Day, Mr Hockney'* and *A Remembered Moment in Venice, California* (figs.66, 67, both 1981–3) give everyday moments an enchanting permanence. They reflect Blake's post-separation situation – his need to take each moment as it comes and his desire to keep friends and family at the centre of his world. They also reassert his masterly skills as a realist painter.

'The Meeting' or 'Have a Nice Day, Mr Hockney' relocates the moment when the three artists were reunited to the boardwalk of Venice Beach. By adhering to Italian Renaissance rules of perspective and in borrowing the composition of Gustave Courbet's comradely group portrait *Bonjour, Monsieur Courbet* (1854), Blake transforms a warm fraternal greeting

A REMEMBERED MOMENT IN VENICE,
CALIFORNIA 1981–91 [67]
Oil on canvas
79.4 × 105.4 (31 1/4 × 41 1/2)
Private Collection

Blake with *Sculpture Park* 1981–3 [68]

into a grand visual statement. He worked from staged photographs of Hockney as Courbet, himself as his patron, and Hodgkin as the servant. The other figures were sourced from pictures in magazines, and the beach itself from photographs taken by the artist on a second trip to LA in 1980. Although deriving from a 'cut-and-paste' eclecticism, the final painting appears seamless. Blake's showmanship is mirrored in his choice of an ornate gilt frame, which mimics 'masterpiece' conventions – apt considering his grand forthcoming retrospective. Yet, the overall impression of the painting is one of lightness, discernible in the gentle humour, the translucent blue of the sky (sky blue being a recent addition to Blake's palette of favourite colours, undoubtedly as a result of the Californian weather) and the radiant glow that infuses his rare use of the landscape format.

A Remembered Moment in Venice, California similarly presents a shimmering, super-real vista, one as expansive as Hollywood's panoramas or Canaletto's Venice. Unusual and revealing in its determined emptiness, the painting captures an instance when Blake was walking back to the gallery from the beach at the end of the day. The sight and sound of a daydreaming girl on roller-skates, gliding across an empty parking lot struck him. Unable to photograph such a transient moment, he worked from photographs of his daughter Daisy. The work is a subtle reflection on being both present and absent.

Alongside the Los Angeles paintings, Blake rekindled his interest in sculpture, turning to remembered moments for inspiration. He made a number of small sculptures and collage constructions featuring natural objects found on daytrips with Daisy and Liberty, and this emphasis on the collection and preservation of treasured objects and memories is similarly expressed in *A Museum for Myself* 1982

(fig.95, p.117). Here Blake's most cherished keepsakes – signed pictures of The Beatles, favourite photographs, pin-badges and so on – are sealed behind glass in a manner that reveals his increasing awareness of gallery presentation. *Sculpture Park* 1981–3 (fig.68), Blake's largest sculpture to date, was also made with the retrospective in mind. With the assistance of Chrissy Wilson, he arranged a vast assortment of miniature objects on a flat surface in a manner reminiscent of some of his earliest experiments with sculpture. The result was a veritable toy town – an open-air museum. Downsized versions of recognisable twentieth-century sculptures by Barbara Hepworth, Henry Moore, Constantin Brancusi, Eduardo Paolozzi and Joseph Beuys, amongst others, congregated on the lawn to illustrate the conceptual and material changes affecting sculpture. In arranging the work of others – often reverently but sometimes with a pointed barb – he assumed the role of curator and critic, asserting the view that artists should be entitled to comment freely. This opinion sits uncomfortably with his parallel belief that critics should not necessarily share this licence.

Those critics who had hoped that Blake's return to London would signal the end of his Ruralist work were disappointed. Distance had intensified his vision of rural life and, although returning to London had confirmed his sneaking suspicion that he was the 'odd man out' within Ruralism, he continued to contribute to group exhibitions and to draw influence from Ruralist themes throughout the early 1980s. He still believed in the importance of traditional figurative painting and admired the work of Victorian artists and writers, and, in the years prior to his retrospective, he made a portrait of Lewis Carroll, based a painting on Edward Lear's famous rhyme 'The Owl and the Pussycat', and expanded his series of

elaborately framed fairies. In continuing the series he was answering any critics who interpreted his return to London as a signal of defeat; the fairies came to symbolise open-mindedness and free expression. The polemical title of a new fairy 'landscape' painting started in 1982, *I may not be a Ruralist anymore but today I saw a fairy in my garden in Chiswick*, asserted Blake's view perfectly.

After an enormous amount of preparation, Blake's Tate retrospective finally opened to the public on 9 February 1983. He had worked closely with Tate curators to conceive the show and consequently his inimitable curatorial vision was strongly felt. *Sculpture Park* sat cheerily in the entrance hall to greet visitors as they arrived; its intentionally low positioning rendered it especially accessible to children. The successive rooms, as in his *Souvenirs and Samples* exhibition of 1977, were hung thematically to express the non-linear development of his oeuvre. A soundtrack accompanied many of the rooms – rock 'n' roll could be heard in the Pop art room whilst the melancholy strains of Elgar and Vaughan-Williams complemented the Ruralist works. To add to the ambience, Ian Dury even wrote a theme tune for the exhibition called *Peter the Painter*. Unlike anything seen (or heard) at the Tate before, the exhibition became a collaborative environment in which Blake felt perfectly at home. The show brought a few disappointments – in the end, since Hodgkin failed to finish his LA pictures in time, the LA installation didn't quite go as expected. It also provided a sense of closure for some elements of Blake's practice: he used the exhibition to mark the official end of his contribution to Ruralism. He had invited each of the Ruralists (apart from Haworth, who was a sculptor) to paint their interpretation of 'The Definitive Nude' for the show. The resulting works, which were

identical in size, marked their last united stand for tradition, skill and beauty.

The show was a remarkable success. During its forty-day run, it attracted almost 60,000 visitors, breaking all previous attendance records for an exhibition by a living British artist. Even the catalogue furthered Blake's populist desire to broaden the ownership of his work: 12,500 copies contained a signed print of *The Owl and The Pussycat* 1981–83 (fig.69). It also included a pamphlet featuring an authoritative anthology of 'Good Reviews' and 'Bad Reviews', revealing Blake's continuing paranoiac fear of criticism. Thankfully, there would be few bad reviews to add to the ongoing collection, for the critics generally responded positively to the show, even some of those who had dismissed his work in the late 1970s. With this renaissance of opinion, Blake at last felt he had achieved the recognition he deserved. Receiving the CBE a few months later only added to his happiness. He went to Buckingham Palace to accept his award from the Queen – a day he remembers as the proudest of his life.

The whirlwind of early 1983 gradually subsided and Blake was pleased to find time to reassess his life and direction. Having reached such a milestone in his career, and aware that he wasn't getting any younger, he felt he should start to 'tidy things up' and not diversify his practice any further. The experience of designing the Tate show had given him a clear overview of his oeuvre, aiding his metaphorical clean up and prompting him to view his future practice less as a sequence of works than as a succession of conceptual exhibitions in which individual works would feature. One of his first ideas was to make an exhibition called *Work in Progress – Finished*, which would finally reveal Tarzan, Titania, Hockney et al in a completed state. Consequently Blake worked hard

on the paintings for the rest of the decade. However, his intention to streamline his production never materialised. To satisfy his need for some short-term diversity, he developed a new-found eclecticism.

In late 1983 Blake travelled to Paris to learn etching under the expertise of Aldo Crommelynck, a specialist who had earlier produced prints for Picasso and Matisse. Having brought a biography of James Joyce with him, Blake continued his interest in literary figures by making a series of etchings based on Joyce's life in Paris during the inter-war years. He also produced a whole series of small-scale paintings of Arabic women, fairies, birds and baby rabbits – studies for a hypothetical painting called *Once Upon a Time*, based on the fairytale fantasies of his two daughters – for a solo exhibition at Galerie Claude Bernard, held in late 1984. And of course there was the regular stream of commissioned portraits, posters, book illustrations, even stage sets. Much to Blake's disappointment, an invitation to design the stage and costumes for the 1984 Christmas production of *The Nutcracker* at the Royal Opera House did not get past the drawing board. However, other projects were more successful.

On a Monday in November 1984 Blake received a phone call heralding a commission that would test his flexibility to its limits. The caller was Bob Geldof, who, having just seen Michael Buerck's shocking news reports from Ethiopia, was determined to get a charity record in the shops before Christmas. Impressed by the *Sgt Pepper's* cover, he invited Blake to design the sleeve for Band Aid's single *Do They Know It's Christmas?* (fig.71). Blake has never aligned himself with social or political causes, but the magnitude of this crisis brought his compassion to the surface. With time of the essence, he turned to the speedy medium of collage for a nimble juxtaposition of Western superabundance with Ethiopian destitution. By the Friday the cover was finished, and the single went on to raise £8 million for Ethiopia. A similar urgency surrounded his subsequent design of the Live Aid concert poster in July 1985 (fig.70). Geldof called Blake on a Friday to suggest the theme of a global jukebox, or the simultaneous occurrence of concerts in London and New York. With just a weekend to complete the work, Blake rushed into the West End on the Friday evening to buy a coloured map of the world. The shop had just closed but he banged on the door and the shopkeeper let him in and sold him the first world map he could find – it was black and white. He spent the whole weekend colouring the map by hand and then applying collage to reflect Geldof's specification. The poster sold out on the day of the concert.

Paper collage would play an increasingly important role in Blake's fine-art practice for the rest of the decade. He borrowed a technique from his commissioned collages such as Live Aid, whereby an existing illustration is enhanced by the addition of assorted fragments. A series of collages entitled *About Collage* 1985 was based on Edwardian hand-tinted prints. For *About Collage: Ostrich Beach* (fig.72) he transformed an unremarkable scene into an extraordinary meeting of man and beast. Fantasy and reality are seamlessly morphed and, as is often the case in his work of this period, the characters appear unfazed by the surreal incidents taking place around them. *Ostrich Beach* also highlights Blake's recurrent interest in excursions. Getting away – to the beach, the park or further afield – is a recurrent subject in his 1980s oeuvre, one that provided infinite opportunities for visual adventure. The excitement of making collages in this vein triggered a curatorial 'excursion': Blake decided that he would exhibit

Original artwork for the Band
Aid single 'Do They Know It's
Christmas?', 1984 [71]
Paper collage
Collection of the artist

ABOUT COLLAGE: TOURIST
ATTRACTION 'OSTRICH BEACH'
1985 [72]
Paper collage
45.6 x 36.9 (18 x 14 ½)
Collection of the artist

KIM NOVAK 1960 and 1987 [73]
Postcards and enamel paint on
hardboard
47.6 x 36.5 (18 ¾ x 14 ⅜)
Waddington Galleries

examples of his own collages alongside his collection of works by both named and anonymous collagists. He would call the exhibition *About Collage* after his recent series, and, although he had yet to find a venue, he started to collect collages with a greater determination.

Blake's desire for escapism perhaps reflected his increasingly isolated position within the British art world at this time. He was receiving scant attention from a scene more concerned with politics and process, performance and photography. Admittedly, these differences had been evident since the late 1960s but, having moved to the country and later worked towards his retrospective, Blake only felt their full impact in the late 1980s. Blake had never experienced such a dearth of common ground with his contemporaries: 'Everything seemed to stop and I wasn't very interested in the artists that were coming through. For longer and longer one was a kind of an impostor.' Pop art was similarly sidelined. Artists such as Jeff Koons were appropriating Pop's consumerist hedonism in the US, but the movement had yet to undergo a renaissance of interest in Britain. Blake felt that a revival, both of his work and his 1960s world, was long overdue.

In 1987 Chrissy gave birth to their daughter Rose. This rejuvenating experience only reinforced Blake's parallel interest in artistic rebirth. The opportunity to fulfil his ambition arose in the same year with an invitation from the Nishimura Gallery in Tokyo to make an exhibition for the following May. He decided to make a Pop art show, choosing the title *Déjà Vu* – 'previously seen' – to justify a complete reassessment of his Pop years. He literally re-made his back catalogue of popular favourites, updating *Toy Shop*, *The Beatles*, *Kim Novak Wall* et al in an attempt to capture the attention of a late-1980s audience (fig.73). He also updated his American Pop rivalry with new art-world jokes (though these wear a little thin in places). The title *Marilyn by Andy Warhol by Peter Blake* speaks for itself, and *Am I too late to be an Abstract Expressionist?* reinvigorated his critique of art-world fickleness. The show was a novel piece of nostalgic navel-gazing, but it did little to reverse the fortunes of either Pop art or Blake's career. It did not tour, thus missing the attention of the British critics, but even if it had, the timing would still have been wrong. It would take a new set of cultural values and a younger generation of artists for Blake to feel at home again in the British art world, and for that, he would have to wait until the next decade.

Blake has always produced work in series, sometimes returning to a subject or idea years after it initially inspired him. His series of wrestling figures is one of his most protracted and diverse, and here he outlines his ongoing love affair with the sport.

I probably started going to the wrestling in 1947. There was a place in Bexley Heath near to where I lived called the Drill Hall, and my mother used to go every week with my aunt and her mother, and I would go with them. There was a tremendous flowering of sport after the Second World War; people were desperate to have entertainment. Television hadn't really started properly and so venues were packed. Wrestling was incredibly popular and I loved it immediately. I loved the theatre, the fantasy and the idea of good versus evil. The very first fight I saw was Mick McManus against a Jewish wrestler called Al Lippman, and for a long time McManus was my favourite wrestler. In those days I would go to the wrestling most weeks, but it peaked while I was at the Royal College, when I would often go two or three times a week.

I can't remember exactly why I started to make the wrestling works. I suppose, along with everything else, wrestling became a valid reason for a series of pictures. I had made some very early boxing lithographs – so there was always an interest – but the series really began with Baron Adolf Kaiser [1961–3, fig.75] *– who is clearly a villain with a name like that! The first wrestlers would have been based partly on showman painting and partly on sign writing. I would have been aware of the wrestling pictures by Bellows & Eakins, and the travelling fairground boxing booths that were painted by fairground artists. To make the wrestlers, I literally took on the persona of a 'maker of wrestling pictures'. Although I knew how to do good lettering, under this guise I did bad lettering! I have always been interested in the way artists work, and in standing back from it, observing it and trying it out.*

In a way, the early wrestlers were a throwback to some of my very first wooden panels, to Siriol *and* Loelia, *where the heads are much too big and they are painted in a very conscious way – like folk art. But later that approach stopped: by the mid 1960s the wrestling works become more like portraits, even though I invented most of the characters. The only real wrestlers I've ever painted are the* Masked Zebra Kid [1965, fig.38, p.45] *– because I happened to get his autograph and decided to incorporate it into a picture, and, much later,* Kendo Nagasaki [1995]. *But usually I would take a real wrestler's head from a wrestling magazine and make it different, give him another name and change his persona.* Doktor K Tortur [1965, fig.76] *was one that I always liked very*

much – I took his image from a photograph of an American wrestler who used to perform as a German. For some reason, at the time it seemed Germanic to ride a horse and drive a Mercedes Benz, so I put models of them on the top and I also included a cigarette holder – it all adds to the distinguished nastiness of him! The point of including objects is always to add to the existing information.

I think including the objects was an invention, or perhaps an extension of some of my earlier sculptures. I suppose it's also based on church art, on votive art, on altars, and on the little silver things that are hung in some European churches – if, by a miracle, your leg gets better you hang up a little silver leg! I would have seen that kind of folk art in Europe in the late 1950s.

Making the female wrestlers helped me to tell different stories. Female wrestling was banned in London. I knew about it through an American magazine called Boxing and Wrestling News, so it was a vicarious kind of interest. Slowly, in the 1980s it became more acceptable, but it was more of a club thing by then and often seemed to be about sex. Female wrestlers were very masculine, very muscular, but my female wrestlers are always very pretty. I took them from girlie magazines and in that way they relate to my series of strippers, but they're about adoration, paying homage, and celebration in the same way as the male wrestlers.

When I moved to Wellow, I probably only went to see the wrestling four times in total. I continued to make wrestling pictures, probably because I missed it. I didn't ever stop being an urbanist really – I adapted to living in the country. At the time I was using a lot of watercolour and so I decided to make a series of watercolour wrestlers. They marked the beginnings of an interest in multicultural Britain and were about the dignity and beauty of difference. Introducing tag teams to the series in the late 1970s made things twice as interesting: I could bring in brothers, I could change the format, and it was also at that time that I introduced sexual variations. Wrestling is incredibly camp – Gorgeous George started all that when he first came into the ring wearing a big ermine coat – often there were straight wrestlers who wrestled as gay men and vice versa.

Kendo Nagasaki is my main wrestling hero. The myth is that he is a kendo expert – he wears the full kendo outfit and mask, and goes through a tremendous ceremony of taking it off. The whole mythology is extraordinary and I still don't know the full story about him! In 1995 we made a film together for Arena television called Masters of the Canvas – me being a 'master' of painting, him a master of the ring. The two quests were that I had to do a portrait of Kendo during the programme, and he had to do an interview.

THE TUAREG

THE TUAREG 1972 [74]
Watercolour
45.7 x 29.8 (18 x 11 3/4)
Anya and Laura Waddington

BARON ADOLF KAISER 1961–3 [75]
Oil on panel
61 x 51 (24 x 20 ⅛)
Arts Council Collection, Hayward
Gallery, London

DOKTOR K. TORTUR 1965 [76]
Acrylic, collage and hardboard
61 x 25.4 (24 x 10)
Michael Chow

I painted him from life, but it was kind of set up. He came and sat but he couldn't stay for very long so Terence Donovan took photographs and I worked from those. I still go and see Kendo; he keeps retiring and then doing a couple more matches and I go and see them.

Generally there are very few matches nowadays, but I'm still making wrestling works – there are always so many possibilities.

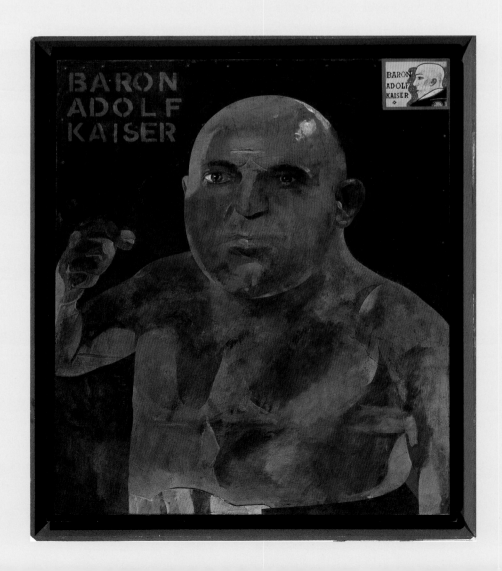

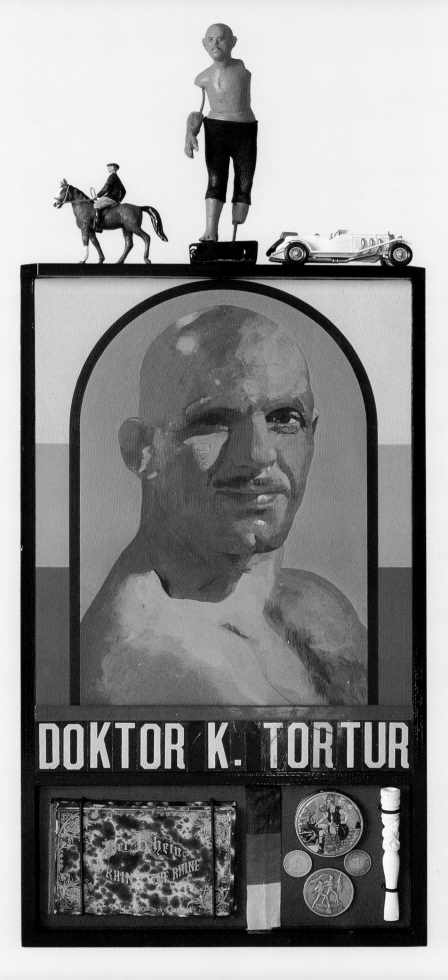

DOKTOR K. TORTUR

TARZAN AND HIS FAMILY AT THE
ROXY CINEMA, NEW YORK
1964–2002 [77]
Acrylic on canvas
182.9 x 152.4 (72 x 60)
Private Collection, Belgium,
courtesy Waddington Galleries

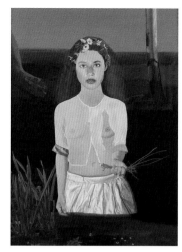

OPHELIA 1977–2002 [78]
Oil on board
139.1 x 96.8 (54 3/4 x 38 1/8)
Private Collection, London/Paris,
courtesy Waddington Galleries
(Also see fig.63, p.71)

YOUTH AND AGE

The dawn of the 1990s presented Blake with a frightening glimpse of his own mortality. In the course of a routine operation, doctors discovered a potentially malignant lump, which, after an agonising week's wait, was pronounced benign. In a candid interview he reflected on his unsettling experience: 'I realised there is going to be a deadline. A Big Deadline. If I am going to die soon, I don't want to leave a studio filled with empty picture frames and half finished paintings.'[29] Acting on these words, Blake, having reached his sixties, returned to canvases started as a young man, but he perceived a change in the way in which he applied paint. His eyesight had deteriorated, and accordingly his heroes of the brush began to change; he moved away from the painstaking precision of Memling to the sensuous simplicity of Velázquez. It is difficult, however, to find evidence of this shift in his paintings, where an extreme clarity of line and detail prevails.

Determined to stave off the ageing process, Blake decided to produce an exhibition each year. He became interested in deceased celebrities who, although not necessarily his favourites, had achieved a certain immortality, and for his first show of the 1990s, *In Homage to Marilyn Monroe* (Waddington Galleries, 1990), he created a series of shrine-like constructions to memorialise the Hollywood star (fig.93, p.113). Just as he had done two years earlier for his *Déjà Vu* exhibition, he assimilated his former self by turning to his early 1960s vocabulary of household paint, primary colours, noticeboards and doors. He planned a companion show, *In Homage to Elvis Presley*, for an unspecified future date (see fig.96, p.118). In a related series of *Homages*, he paid respect to his favourite artists. Although he had previously referenced other artists in his work, the *Homages* are genuinely reverential, with none of the playful imper-

tinence of his earlier appropriations: like any fan he could simply stand back, admire and emulate. For a series entitled *In Homage to Collagists*, he surrendered his personal style in order to enter the mindsets of his idols Kurt Schwitters, Joseph Cornell and Max Ernst, amongst others. He selected subjects they would have chosen, and carried out an eccentric performance to bring them to fruition: 'For a little while you pretend you are that person and take on their character. While I'm doing the Schwitters collage for instance, I'll trawl around and if I see something in the gutter that I want to use I'll pick it up and bring it back.'[30] In paying homage, he worked as a kind of ghost-artist – continuing the careers of the deceased.

The resurrection of Blake's career happened quite naturally as the British art world returned to his way of thinking in the early 1990s. *Pop Art* – a major retrospective of the movement that opened at the Royal Academy in September 1991 – helped to bring Blake and the 1960s back into the public consciousness. Furthermore, he was no longer the black sheep in the British art flock. The so-called 'Young British Artists', who had recently graduated from Goldsmiths College, had caused a stir since their exhibition debut in 1988, and dominated the British scene throughout much of the 1990s. Their work, much of which celebrated British popular culture with a quirky irony and vulgarity, was accompanied by a social lifestyle of hedonism and collaboration. Noticing the similarities with his life in the 1960s, Blake became an ardent supporter of the Young British Artists – a kind of grandfather figure – making their acquaintance and attending their exhibitions and parties. He perceived deep correspondences between works such as *Girlie Door* 1959 and Gary Hume's paintings of beautiful women using household paint, and he also identified with Tracey Emin's application of words and pictures

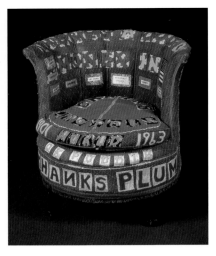

Tracey Emin
THERE'S A LOT OF MONEY IN CHAIRS
1994 [79]
Appliquéd armchair
69 x 53.5 x 49.5 (27 ⅛ x 21 x 19 ½)
Courtesy Jay Jopling/ White Cube
(London)

to faded domestic objects (fig.79). But it was with Damien Hirst that he struck a particular chord. Hirst remembered the impact that *Girl at a Window* 1962 in Leeds City Art Gallery had made on him as a student, and his subsequent use of neatly stacked cabinets and his deployment of voyeurism may derive in part from Blake's influence.

As the art world changed in Blake's favour, so did the culture upon which it fed. Years of political correctness and collective guilt had given way to a culture seemingly more relaxed. Young men in particular were beginning to feel more at ease with being themselves, and a new breed of magazines such as *Loaded* and *FHM* celebrated the young male life-style in all its variety: beautiful women, sport, music, 'freaks' and 'oddballs' – all conveyed with a cheeky humour. This same honesty and acceptance of male tastes had preoccupied Blake for decades, but not since the 1960s had he stumbled across such common ground. His renewed relevance is demonstrated in *The Alphabet* 1991 – an edition of screenprints based on a series of collages. The twenty-six images reveal his lifelong love of order and categorisation by depicting one of his many favourite subjects to represent each letter: *A*lphabet, *B*oxer, *C*lown, *D*warfs & Midgets, *E*verly Brothers, *F*ootball, *G*irl, *H*eart, *I*dols . . . His visual lexicon confirms that, despite being in his sixties, Blake was the consummate 1990s lad, and his relevance would only increase as the decade unfurled.

But Blake was equally capable of playing the role of Old Master. In December 1993, the National Gallery invited him to become its Third Associate Artist on the strength of his appropriation of past art in his earlier work. His brief was simply to produce new work in response to the collections, and to stage an exhibition of his output at the end of his two-year

tenure. Although busy with various commissions and portraits at the time, he readily accepted, and, to acquaint himself with the collection, one afternoon he walked around each of the sixty-six rooms in numerical order, examining each picture along the way. This preliminary perambulation triggered a number of initial intentions: he predicted that his final show would comprise ten finished paintings, including a painting called *The Venuses' Outing to Weymouth* (fig.80) in which some of the gallery's goddesses would sunbathe in Constable's *Weymouth Bay c.* 1816 and an update of Pietro Longhi's *Exhibition of a Rhinoceros at Venice c.* 1751 featuring Venice Beach. But once he had settled into the Gallery studio in August 1994 the ideas rushed out. He reassessed the residency as a time for new ideas not painstaking details, and consequently commenced over fifty paintings, some no more than sketched outlines. The residency provided a period of carefree experimentation akin to his student days.

Characteristically, Blake worked in his studio from reproductions, rather than out in the galleries. With a fistful of postcards he could view the collection not through traditional categories of geography or chronology but through his own a-historical classifications. He tended towards the gallery's holdings of mythological or genre (landscape, portraiture and still-life) paintings – not surprising considering the themes of his own work. Sometimes he reinterpreted entire paintings in his own style: the brawny fighters and curvaceous courtesans in Lucas Cranach the Elder's *The Close of the Silver Age* 1527–35? naturally fascinated him. But more often he took snippets from different paintings and presented them together on a single canvas (as in *The Venuses Outing to Weymouth*) or separately on small canvases to form a series. *The Nine Prettiest Bottoms in the*

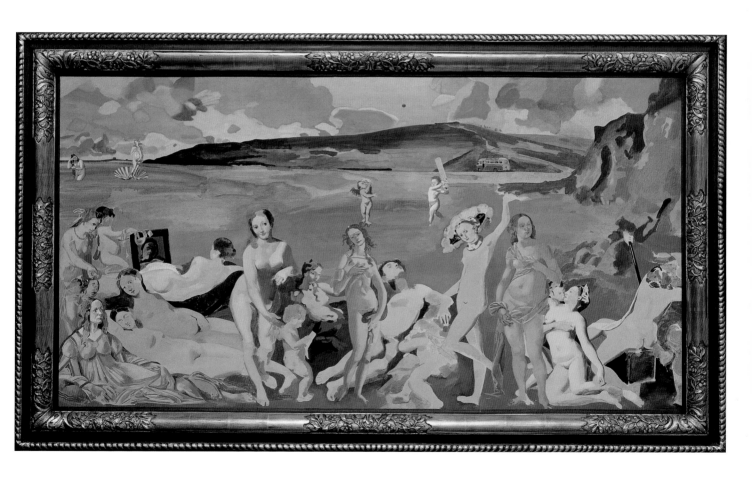

National Gallery, for example, comprises nine canvases each featuring an almost abstract close-up of one of his favourite posteriors by Velázquez, Boucher and Renoir, amongst others. His aim was to be 'completely politically incorrect' and to infuriate the art critics by acknowledging his natural male response to such imagery. He knew the original paintings were strong enough to take the joke.

Despite his agnosticism, religious subjects did not escape Blake's attention. He had obediently interpreted Bible stories as a student and had since accepted the odd commission on a religious theme, but only at the National Gallery did he choose to paint religious imagery, finding in it a unique strain of magical realism. He studied the huge proportion of Virgin and Child paintings in the collection and, in realising how defunct the genre had become in twentieth century art, decided to revive it, just as he had earlier updated the genre of fairy painting. He based *The National Gallery Madonna* (fig.82) on Bartolomeo Montagna's *Virgin and Child c.* 1485–7 (fig.81) from the reserve collection. Drawing inspiration from the way in which earlier artists had located the Virgin and Child in their own times, he gave the Virgin the features of the 1990s model Cecilia Chancellor, and mid-1990s London can be seen through the gallery windows behind her. The scene, which is lovingly and masterfully painted, exudes a deep sense of peace, offering an autobiographical reference to the closeness that existed between the young Blake and his mother. Correspondences between sacred and profane modes of female adoration also underpin the *Madonna of Venice Beach* series of paintings in which Blake transports the Virgin to sun-kissed LA boardwalks, using a sugar-candy palette where red, white and blue appropriately predominate. In *Madonna of Venice Beach I* 1996

THE NATIONAL GALLERY MADONNA
1994–2000 [82]
Oil on canvas
121.9 x 91.4 (48 x 36)
Waddington Galleries

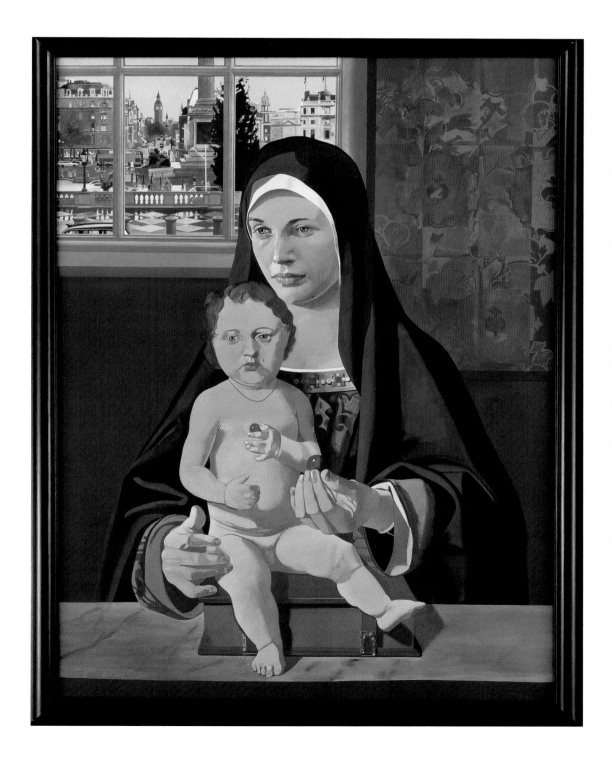

(fig.84), for example, the Virgin and Child from a Dieric Bouts painting appear to be unruffled by the presence of a naked Madonna Ciccone dangling from a helicopter nearby and her look-alike roller-skating before them. The Virgin accepts her celebrity inheritors in the same way that Blake allows the younger generation and popular culture to remain ever-present in his work.

During his time at the National Gallery, Blake undertook a wide range of commissioned portraits, advertisements and record sleeves. Perhaps the most significant of these was his cover design for Paul Weller's *Stanley Road* album (1995, fig.83), which helped situate Blake's work within the 'Cool Britannia' culture of mid-1990s Britain. He was flattered to be asked by Weller to design the cover – they both shared a love of The Beatles, the 1960s, London life and Mod imagery. Just as he had done nearly thirty years earlier with The Beatles, Blake asked Weller to make a list of his favourite things, to be incorporated into a collage. The resulting work mimics the conventions of a corny birthday card: the musician's interests are expressed via a range of symbolic accoutrements. Considering the mutual interests of Blake and Weller, it comes as no surprise that the cover is as much a 'portrait' of the artist as it is of his 'sitter'. In the centre of the composition sits a small painting showing Weller as a child, holding an image of himself as a grown man. This impossible scenario perfectly reflects Blake's feelings of being at once young and old, in the past and the present.

Blake's National Gallery exhibition, *Now We Are 64,* opened to the public in September 1996. It was his largest exhibition since the Tate retrospective, bringing together the residency paintings, earlier pieces referencing the work of other artists, and two years of his commissioned artwork. But there was a

reason for the title *Now We Are 64*: another artist was involved – Cheetah the chimp. During the residency, Blake had worked on *Tarzan and his Family at the Roxy Cinema* 1964–2002 (fig.90) and, in searching for a picture of a chimpanzee, had stumbled across a feature about the animal star himself. It transpired that Cheetah, an LA resident who was exactly the same age as Blake, was staging an exhibition of his paintings to save up for a larger run for his retirement. Blake, hoping to sell enough paintings to afford a new studio, felt they had much in common and decided to include a couple of Cheetah's colourful abstracts in his show, much to the delight of the press – most of whom took the joke. On the whole, Blake's work was similarly well received. In *The Sunday Times* Waldemar Januszczak praised 'the moments in which the joking and referencing ceased, and Blake allowed himself to paint purely and beautifully'.[31] But others found the jokes just too thin: Adrian Searle decreed that Blake was 'less an artist at play than a man regurgitating the ill-digested banquet of the National Gallery'.[32] Such criticism, however, failed to tarnish Blake's joyful experience at the gallery.

The closure of the exhibition in January 1997 felt like something of a retirement: having reached such a pinnacle in his career at the age of sixty-four, Blake felt that it was time to step off the career ladder and pursue a different philosophy. He decided to retire *emotionally* from the art world, but would return from time to time with a series of comebacks, or 'Encores' as he called them. As he expresses in the accompanying text, the Encores can take various forms: new works, completed works, exhibitions, illustrations, plans for which might have occupied his thoughts for decades. In many ways, the Encores concept is essentially a reiteration (albeit unconventional) of Blake's life-long desire to pursue an

MADONNA OF VENICE BEACH I
1994–6 [84]
Oil on canvas
137 x 84 (53 $^7/_8$ x 33)
Private Collection, London,
courtesy Waddington Galleries

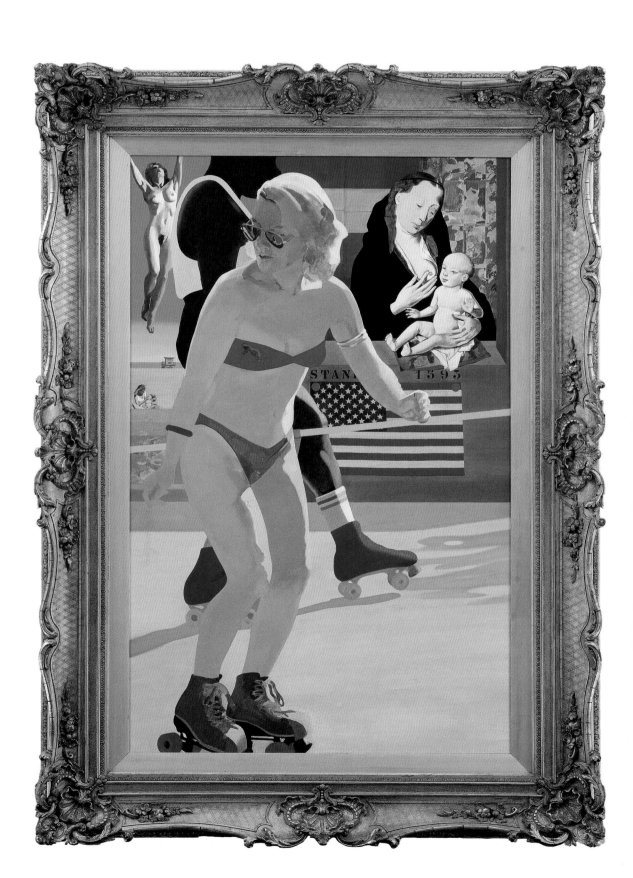

Above: The sculpture studio,
January 2003 [86]

Left: The collage studio,
January 2003 [85]

enormous range of works in whichever way he chooses. But it also enables him to view his life and work as an ongoing piece of performance or conceptual art. In borrowing a code of conduct from the world of live entertainment, he has consciously become the ringmaster of his own world.

Blake's development of his *Encores* lifestyle corresponded precisely with his move to a new studio in January 1997. For a long time he had felt the need for more space. His studio at home, which provided just 20 feet square of room, restricted his output and consigned much of his beloved collection to storage. The new studio – a converted Georgian stable in an inconspicuous corner of West London – provides 3,500 square feet of floor space on two levels. The studio is divided into different areas to accommodate the many facets of his practice: a collage studio in which intricate Victorian screens cover the walls from floor to ceiling (fig.85), and a sculpture studio filled with boxes of driftwood, cabinets stuffed with dummy parts and intricate ornaments (fig.86). The painting and printmaking studios are simply whitewashed and flooded with natural light. There is also a library, a 'nightclub' for socialising (complete with cosy chairs and parlour palms), and plenty of room throughout the studio for the display and storage of Blake's ever-growing collection.

Since taking up residence, Blake has arranged the collection in his own inimitable style to build up an extraordinary world, a magic toyshop. His entire life is carefully stacked, compiled, labelled: on display. Ultimately, rooms, collections and works-in-progress commingle to the degree that one begins to wonder if the studio is in fact his greatest masterpiece. Even he has had trouble with its definition:

'*It is a museum, but not entirely so until it has nothing to do with me. It is also my working space and the objects that are on view are either for decoration or ready to use in future work. In a way the whole thing is an environment, and even the way I place books on a shelf is controlled. Controlled, but very flexible and certainly not precious. I don't move things half an inch! . . . The studio is a living, changing-all-the-time space – essentially a big collage or an amorphous kind of monster.*'[33]

Setting up the studio required Blake's full powers of collecting, display and curatorship and his renewed interest in these areas informed many of the exhibition-based Encores that followed. *A Cabinet of Curiosities from the Collections of Peter Blake* held at the Morley Gallery in 1999 presented his selection of some of his favourite acquisitions. In the following year his *About Collage* exhibition was finally realised at Tate Liverpool to great acclaim. His collection of collage hung alongside examples from the Tate, plus a few surprises. To mark his respect for the city and its musical past, he included collages by John Lennon and Holly Johnson, and a 'Liverpool Sound Collage' made by his friend Paul McCartney, which could be heard throughout the gallery. Keen to attract young audiences and fans, Blake included two collages by Robbie Williams, which were made after a visit to his studio, marking the beginning of their friendship. The show underlined Blake's desire to be surrounded by crowds of objects: curios neatly stacked in deep recession, pictures hung five or six deep covering every available surface. Despite the inclusion of work by other artists, this exhibition, like the studio, was about his world: it became an installation.

With age, Blake has acquired an establishment status, one that he has both accepted and denied. He has never wanted to be 'middle-of-the-road and elderly' – characteristics he has perceived to be in evidence at the Royal Academy, an institution in

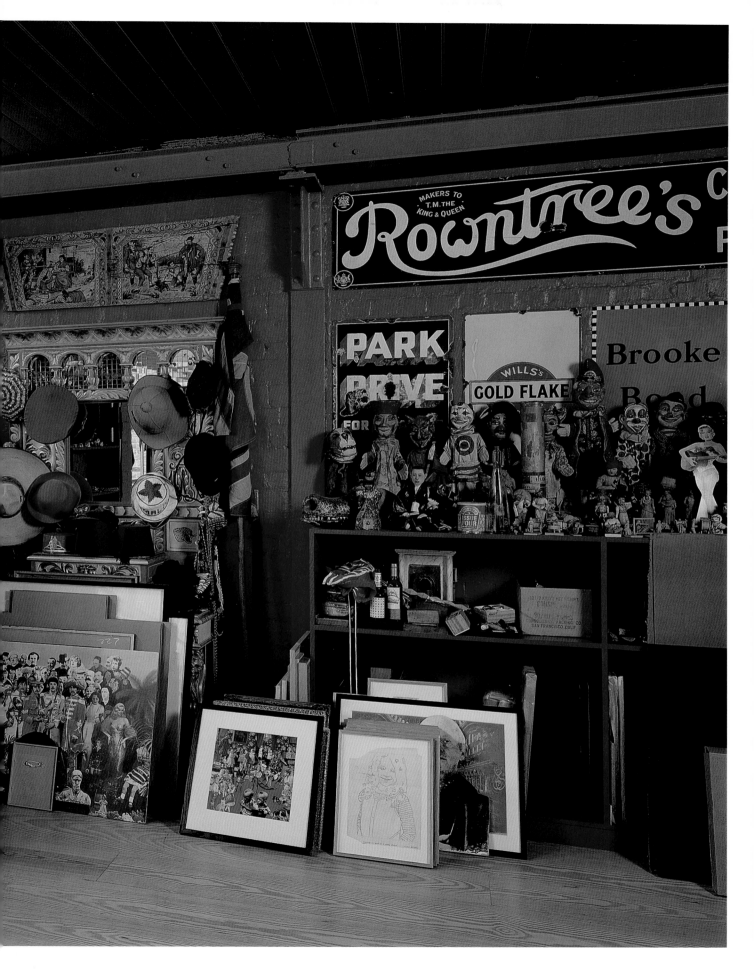

ROBBIE WILLIAMS 2002 [89]
Acrylic on board
42.5 x 31.6 (16 3/4 x 12 1/2)
Robbie Williams

which he still plays an active role. In 2001 he was appointed Senior Hanger of the Academy's annual Summer Exhibition and he used the opportunity to update its outmoded conventions. His most controversial ruling was to reduce the number and size of the paintings that Royal Academicians could submit. He also made an open selection of works for one of the rooms, his criterion for selection being that he 'had to be a fan'. Some of his favourite popstar painters – Paul McCartney, Ronnie Wood, and the late Ian Dury – were represented alongside work by a number of Young British Artists, most of whom were delighted to contribute, as Gavin Turk testified: 'We all love Peter, I'm sure he could twist my arm. I think Tracey and the rest would be up for it too.'[34] Although relatively mild, Peter's paean to youth and popular culture was a step too far for conservative minds. Despite his years, he is still the young rebel at heart.

At the time of writing, Blake continues to work with a remarkable consistency and commitment. He travels from Chiswick to the studio every day on the bus, dressed, whatever the weather, in a waistcoat and a shirt fastened with cufflinks made from the 'P' and the 'B' of an old typewriter. This attire perfectly suits his ringmaster-like responsibilities in the studio, whilst being smart enough to greet the regular stream of interviewers and visitors who punctuate his routine. Although he is constantly working on an enormous range of different projects in a wide range of media, painting is a feature of most days, and the brushwork is exquisite, timeless, heartfelt, jewel-like: unlike much else in contemporary art. The paint comes alive in a magical way on the canvas, changing on a daily basis. Sometimes Blake will start a new commission – in recent years he has made a radiant portrait of his friend Ian Dury (fig.90) for a tribute album, and a portrait of Robbie Williams (fig.89)

intended for the album cover for *Swing When You're Winning*, commissions that underline Blake's continuing involvement with the unmistakably British impulse in popular music. But, more often he turns to his other good friends – the characters of his works in progress, such as Tarzan (fig.77) and Ophelia (fig.78) – who remain perpetually young, thanks to his regular flattering face-lifts. But, through necessity, these works are beginning to leave the studio one by one to pay a bill or two. Each departure prompts Blake to feel a certain disappointment and loss – a sense of satisfaction is never really reached: his dilemma as a painter has become less about the level of finish or unfinish, and more about the death of the process itself.

In the evenings Blake works from the studio at home late into the night on exquisite drawings and book illustrations, the lines so fine they draw breath. Otherwise he travels into the city with Chrissy to attend parties and gallery openings, always making new friends, having fun and drawing inspiration from the 'urban buzz'. For Blake, youth and age, art and life are inseparable, magical; to be celebrated to the full.

IAN DURY 2001 [90]
Acrylic on board
30.5 x 25.4 (12 x 10)
Waddington Galleries

ENCORES 1996

Many artists experience a flowering of creativity in old age, and Blake is no exception. On reaching sixty-five he formulated the 'Encores' concept – a design for life that has enabled a new sense of freedom and possibility. Here we reflect upon his unusual notion of retirement, the incredible range of his late work, and his plans for the future.

NATALIE RUDD How did you arrive at the 'Encores' concept?

PETER BLAKE I was Associate Artist at the National Gallery from 1994–6. At the end of my time there, I realised I would be sixty-five the following year – the age of retirement for a male. Being at the National Gallery had been an extraordinary time. I'd done a lot of work in two years and had shown in the best gallery in the world. So I thought, 'OK, you'll never reach this peak again, so, announce your kind of pretend retirement.' It wasn't a stunt or anything; it was just that things had come to a conclusion. So, it's a kind of emotional retirement. I've retired from the battle in a way. I'm not competing with the young artists. I'm not jealous of wealth or success. It's given me an inner peace just to put things to one side and approach things in a different way. To put it in terms of theatre, there had been various peaks in my life: the end of the second act had been my retrospective at the Tate in 1983, and the show at the National Gallery was the big finale. Out of that came the idea that I wouldn't stop working, but I would have a series of encores, as you do in the theatre – when you come on to do an encore, you can do something else. In a way it's opened a new door. It's changed the rules. The new set of rules allows for the fact that every so often I can do one of these Encores, and it doesn't have to relate to the general picture.

NR Which of the Encores have already occurred?

PB So far the main ones have been the show at the Morley Gallery of my collections called *A Cabinet of Curiosities* and the show at Tate Liverpool, *About Collage*, which brought to a conclusion my interest in collage. I think the studio has enabled the encores to happen. I moved in January 1997, and for the first time I've had almost more than enough room – room for pretty much anything. It's also one of the encores in a way; it's a kind of event. Many people say it's like a museum, but I haven't done it to be like a museum. It's my environment. It's where I work. But I have to admit there are collections and it is beginning to be a bit like a museum.

NR What plans do you have for future *Encores*?

PB I'm working on a show called *In Homage to Elvis* [fig.96], which includes ten shrines to Elvis Presley and a collection of ephemera. There's also a possible sculpture show, and an exhibition of drawings. Then there's a show called *1-10*, which is about the fact that I don't always work in one style. So the idea is that '1' is one picture of a certain kind and '2' is two pictures etc. So, at the moment: '1' is the large version of *Museum of the Colour White*; '2' is two small Marilyn pictures from my *In Homage to Marilyn* show in 1990; '3' is three of the heads from the National Gallery *In Homage to Woman* series, and so on. The other conceptual show is *Work in Progress: Finished*.

Player's Cigarettes

White Leghorns

RA OB

White Artists' Water Colour

Series 1 AA

USA NASA Columbia

ILLUSTRATION FOR DYLAN
THOMAS'S 'UNDER MILK WOOD'
1990– [92]
Pencil on paper
29.5 x 21 (11 3/4 x 8 3/4)
Collection of the artist

Over the years I've followed this concept of 'work in progress' – working on paintings and exhibiting them in different stages – I worked on the Tarzan picture for thirty-eight years! But out of necessity I'm now finishing the paintings one at a time – and they're going to different collections, so I'm not sure if that show will happen. But there are so many other things in progress. I'm suddenly going to be showing in New York, for the first time in forty years. I'm to make some half life-size sculptures on a circus theme for the sea front in Blackpool, and I want to make an edition of quarter-size wrestler heads. I haven't modelled in clay for a long time so I really look forward to doing that. I'll finish the illustrations for a new edition of Dylan Thomas's *Under Milk Wood* [fig.92], and I might illustrate the Molly Bloom soliloquy from James Joyce's *Ulysses*. And then other things will just happen – I'll have another idea just like that, suddenly, but I don't know what it is yet. I've got so much that I must try and finish that in a way I don't even have to worry about starting anything else – but I know I will.

NR Is the art of finishing as exciting as the art of starting?

PB It can be, although it's sometimes very hard work. I think this need to bring things to a conclusion is simply about me coming up to my allotted time. You have your three-score years and ten, and psychologically, anything beyond that's a bonus. So I think in a way it's probably *that* coming closer that makes me want to tidy up.

NR How would you like to be remembered?

PB What I hope I'm *not* remembered for – although I'm still convinced that a lot of my contemporaries think this – is for being a lightweight artist. I hope I'm not put to one side, just because there's humour and because the pictures are often quite light in subject. I hope that when people look back – like when I look back at Millais – they'll say, 'Oh, he's painted that beautifully.' I hope people kind of liked what I did.

NR The Encores express an awareness of one's mortality, yet at the same time they're incredibly rejuvenating. This sense of vitality seems to extend into your life too.

PB Yes. I think I've just kind of stayed young. On one level I suppose it's about clinging on to a childhood that didn't happen, and that was nobody's fault. But in another way, youth has come to me – I mean, Paul Weller asked me to do his record cover and I think that's about a kind of respect. I also see a lot through my daughter Rose's eyes. She keeps me young – she's only fourteen – and she tells me to shut up when I'm being silly.

2

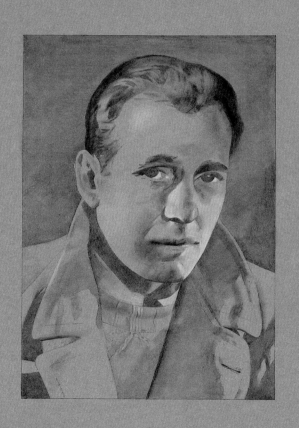

Second Voice. Peter Blake. 2002

[Peter Blake's] attitude to the mass media is neither theoretical nor primitivistic; his art is a natural record of 'people I like', mounted in forms that combine the intimacy of tackboards with the impact of public signs. Blake works as a fan.[1]

Blake was a fan long before he became an artist. His eventual entry into the art world did not diminish his fan status – it substantiated it. He was probably the first artist in post-war Britain to establish and maintain fandom as a legitimate and productive base for his practice. Tapping into his own enthusiasms or mirroring those of others, Blake has produced work in a variety of media that exudes a fan's devotion. Work made from this perspective can be found at all points in his career, from his earliest paintings of boys wearing badges, to the collage-constructions made in homage to stars of the 1950s and 1960s, to his most recent portraits of celebrities such as Robbie Williams, intended for a record cover design (fig.89, p.106). At the heart of such work lies an acute interest in and understanding of fandom, regardless of whether or not the stars featured are Blake's personal heroes. His aim is to 'get right in with the pin-ups and Elvis . . . and inside every house that has plastic flowers and curtains',[2] so as to investigate the ways in which being a fan manifests itself visually in choices of dress, for example, or the presentation of images and objects within the home environment – on walls, in cabinets, on doors.

Fans were receiving scant or unfavourable consideration from commentators and theorists at the time when Blake first started to consider the subject. 'Beatlemania', for example, was perceived by many as a debilitating illness, one of great danger to the mental health of young women. Recurring instances of celebrity stalking have similarly swayed society's view against fan culture over time. But Blake has never supported the popular stereotype of the fan as a passive receptor of popular culture, or as an obsessive, potentially dangerous individual who, out of uncontrollable desire for an unobtainable icon, rejects the rational self. Rather, he respects the fan as an active participant who negotiates the products of popular culture in playful, creative and sophisticated ways. For Blake, the figure of the fan – be it himself or another – is a potential source of inspiration.

In recent years many thinkers have come round to a more positive view of the fan, one more akin to Blake's own.[3] His work has also anticipated a younger generation of innovative artists who have embraced the notion of the artist as a genuine fan, or as a kind of anthropologist assessing the idolatrous tendencies of pop culture. The paintings of the American artist Elizabeth Peyton (b.1965), for example, depict the heroes of today – including Jarvis Cocker, Leo DiCaprio and Liam Gallagher – with a heartfelt affection and dedication and the British painter Dexter Dalwood (b.1960) depicts his interpretation of private celebrity spaces such as Kurt Cobain's greenhouse and Prince's Paisley Park studios. The objective of Cornelia Parker (b.1956), on the other hand, is to carefully preserve and display forgotten relics such as the fine residue left by the cutting of a Beatles record at the Abbey Road Studios.

Yet, although artistic and academic research into celebrity and fandom is now substantial and far-reaching, little has been written about the natural correspondence between fan behaviour and aesthetic awareness. Through an assessment of how fans use objects and ideas within the domestic environment to

UNTITLED, from 'IN HOMAGE TO MARILYN MONROE' 1990 [93]
Gloss paint and mixed media on wood
67.6 x 81.3 (26 5/8 x 32)
Waddington Galleries

support their heroes, I hope to cast light on the natural correspondence between artist and fan, gallery and home, with a view to broadening our understanding of a major source of Blake's art. The points made here are drawn from a consideration of the available literature, and from an investigation into the work of fans carried out as part of the *Pin-up: Glamour & Celebrity since the Sixties* display that I co-curated for Tate Liverpool in 2001. In presenting celebrity portraiture from the Tate's collection alongside documentation of pin-up displays created by fans in their homes, the display examined the shared investment in celebrity figures made by artists and fans, whether in a gallery or domestic context.[4]

BEHIND CLOSED DOORS

The home is often perceived as a static place, far removed from the outside world, where stability and familiarity tend to override flux and experimentation. Yet it actually allows for a far greater degree of flexibility and creativity than is often presumed. For a start, the home tends to be a place of intimacy and privacy: there is no need to assume a social or professional face there. Being at home allows us the opportunity to be ourselves, to engage with our favourite interests, to fantasise and to create our own private worlds. In this respect, the home is a liberated space within which fans can freely pursue their enthusiasms. With this in mind, it is no coincidence that until 1994 Blake always worked from a studio within the comfortable confines of the family home. His new studio similarly reflects the structure of a traditional house in that it is divided into rooms for both domestic and creative activity.

Not only does the home support the psychological liberation of the fan, it also provides a receptive and open space in which to work. It is easy to dismiss the home as too closed an environment for the fan – after all, the object of a fan's affection lies outside, in the distant and glamorous world of fame. Yet, despite its geographical remoteness, the world of celebrity enters the home on a daily basis via television, radio, the Internet, magazines and newspapers. Paradoxically, it is within the ordinary home that the transient world of celebrity finds permanent form.

Of course, many fans invest much time outside of the home, seeking ways to obtain a greater contact with their heroes – a precious sighting, perhaps, or a pilgrimage to a site of special significance. Yet one of the primary objectives of fan activity within the public realm is to acquire meaningful objects and imagery relating to their idol, from the purchasing of 'official' merchandise to the hunting down of rare finds in flea markets and second-hand shops. Shopping is a major element of the fan's practice, inherently involving the transference of objects from public to private space.

PRIVATE COLLECTIONS

A collection is a key way through which fans give physical and multifaceted form to an otherwise unobtainable icon. Consequently, emotional investment in a collection can be immense, regardless of its financial worth. Fans often adopt an inclusive approach to what is primarily a biographical form of collecting, based on a desire to build up the fullest possible account of their heroes. Numbering and counting, as frequently evidenced in Blake's work, become important activities – having twenty-five images of Elvis, for example, presents a much fuller sense of him than any single image could. Yet fans also apply a strong sense of discrimination and an expert

GIRLIE DOOR 1959 [94]
Collage and objects on hardboard
121.9 x 59.1 (48 x 23 1/4)
Private Collection

knowledge to the assessment of their collections. They are acutely aware of the relationships between different groups of objects and are quick to form hierarchies and preferences. Out of the mass, a limited group of objects is bestowed with a special significance. Blake's *A Museum for Myself* (fig.95) – in which his most precious objects are presented with a curatorial precision and preserved behind glass – illustrates this process clearly.

Judgements concerning authenticity lie at the heart of the fan's response to his or her showpieces. The genuine provenance of a prize possession becomes all-important – are those scrawls *really* The Beatles' signatures? The most precious objects in a collection are often those that have been physically touched by the idol in some way: the second-hand object allows for a greater proximity to the hero. Blake, who has expressed a specific interest in star-touched relics, explains: 'I like the idea of having a piece of somebody – having their autograph or a photograph of them.'[5] This need to own an object imbued with a human presence helps to explain the fan's fascination with the domestic situation of the hero. If home is conducive to self-expression and liberation, then owning an object from the site where the hero feels 'at home' enables the fan to feel closer to the true personality. Pilgrimages to celebrity homes such as Graceland, scavenging for fragments from a star's dustbin, or purchasing items from a celebrity's wardrobe are all common fan pursuits – Blake, for example, owns a pair of tiny boots which once belonged to Tom Thumb – the renowned nineteenth-century midget entertainer, and a framed fragment of yellow gingham, which, according to the accompanying 'certificate of authentication', once formed part of Elvis's tablecloth.

Many fans perceive their collections to be in a constant state of transformation, open not only to growth via purchase or gift, but also to the influence of new interpretations over time. Objects are invested with an almost talismanic power capable of awakening not just the life of the hero, but also, via the evocation of associated memories and feelings, the life of the fan. In this way, the collection becomes a kind of portraiture, a diary, even, of both hero and fan. It is this conceptual intermingling of past and present, fact and fantasy, self and other that renders a fan / collector's enterprise so creative.

CHANGING ROOMS
The notion of the family home as a personal gallery reflecting the enthusiasms and collections of the owner is by no means new: one only has to think of a stately home, its rooms adorned with paintings and objects reflecting the tastes of its aristocratic owners, to grasp the longevity of this concept. On a less grand scale, each of us assumes a curatorial responsibility when it comes to home decoration: we make aesthetic decisions as to what, why and how we exhibit objects within the home. Fans, with their sensitivity to the potential of collecting within the context of domestic space, can be among the most inventive of us when it comes to display.

The wall is the primary site for the two-dimensional material collected by fans. Unlike the 'minimal look' to which many households nowadays aspire, the fan's aesthetic often tends towards visual overload. The room becomes a total environment in which a patchwork of pin-ups is sewn into the fabric of every available surface, a rectilinear tessellation forming naturally out of the traditional centrefold format. The correspondence between these collection displays and the fine-art

A MUSEUM FOR MYSELF 1982 [95]
Mixed media
115.3 x 86 (45 3/8 x 33 7/8)
Collection of the artist

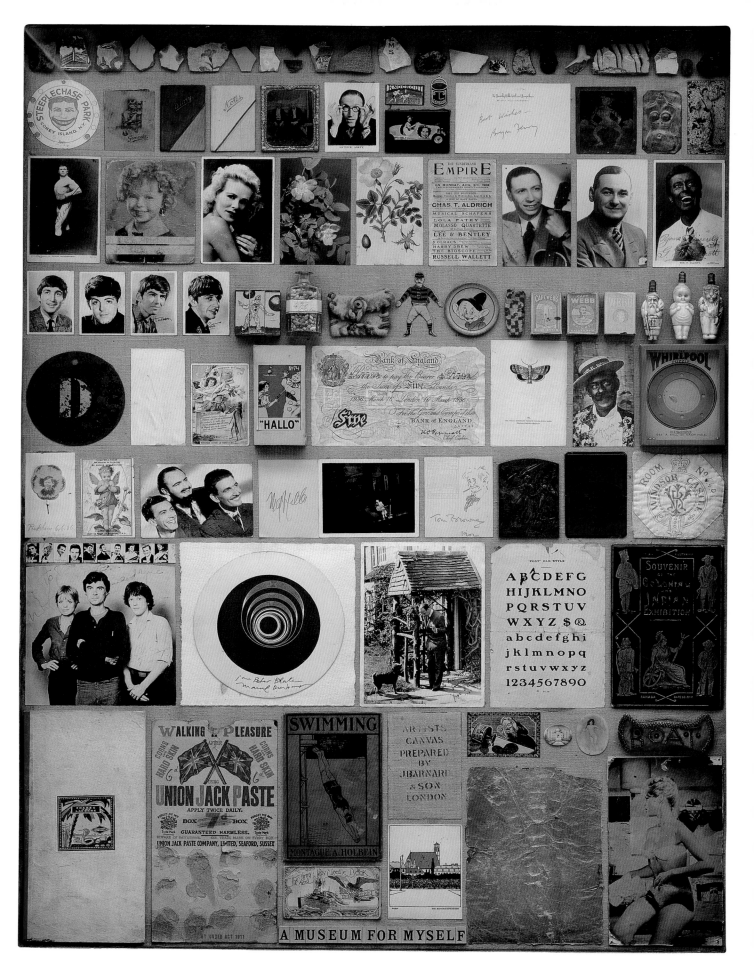

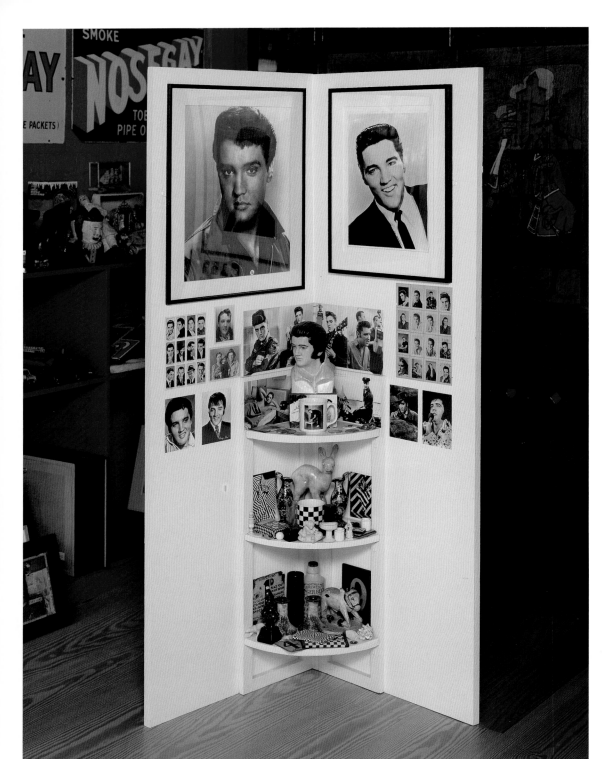

Blake's *Elvis Shrine* in the studio,
January 2003 [96]

practices of collage and installation are instructive, since similar decisions concerning concept, selection and intention inform each. Yet despite the need to embrace a holistic approach, fans rarely jeopardise the autonomy of the singular object. Images often touch but they rarely overlap. Because each element is of individual significance to the fan, it is presented in a consciously objective way so as to reflect this pride and affection, and to allow its meaning to resonate as a singular unit within the whole.

Of course, when other members of the household are present, the process of home decoration involves much negotiation. The need to forge a peaceful deal often circumscribes not just the sites in which the fan's collection can be displayed, but also the degree to which it predominates within shared space – this process especially takes hold as the fan reaches adulthood, as even the bedroom becomes a site of partnership rather than individuality. Compromise can come in the form of a special place: one Elvis fan, with the agreement of his partner, decreed the toilet an Elvis display zone. The worlds of fantasy and function are here wittily combined in a way that concentrates fan creativity within a contained space, leaving the rest of the house free for the application of a more conventional, mutual taste. For other fans, maintaining domestic equilibrium necessitated the storage of collections in cabinets or boxes, out of sight yet no less precious, as much of Blake's work using these formats demonstrates. Blake himself now has the best of both worlds: a contented family life *and* a second 'home' – the studio – which houses his collection and gives him the freest rein to experiment with its display potential.

IN THE PICTURE

In addition to the practices of collecting and display – the arrangement of existing paraphernalia – there are other forms of fan production that involve the creation of new material. As we have seen, collections can operate as figureless portrayals of the admired and the admirer. This interest in representation explains why figurative forms of portraiture are also of great interest to the fan, the urge to portray deriving less from proven artistic skill than from the desire to interpret their hero's features personally, without the mediation of the press photographer. The simple snapshot capturing the briefest glimpse of a hero, for example, means more than any professional photo shoot could. Ideally the snapshot would feature the hero with one arm draped round the fan so as to certify the moment of contact. Cherished images such as these are often framed and displayed on the mantelpiece, as if the hero were some long-lost family member: further proof that fandom is as much to do with the self as the celebrated other.

This peculiar blend of portraiture and self-portraiture also emerges when more traditional media are used. A traced pencil image of a pin-up, for example, effectively unifies the star's face with the fan's hand. When the fan opts to work from imagination, an even greater proximity to the star can be achieved. Anything can happen on the blank picture surface. One fan painted a double portrait of herself and her heroine, Audrey Hepburn, both dressed in a similar fashion. Although heartfelt and intimate, the painting is ultimately a work of fantasy and aspiration, one that documents a conceptual rather than an actual encounter.

A decorative display created by an Elvis fan for his toilet wall [97]
Courtesy Tate Liverpool

A fan's collection of Daniel O'Donnell photographs [98]
Courtesy Tate Liverpool

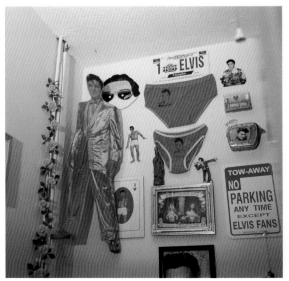

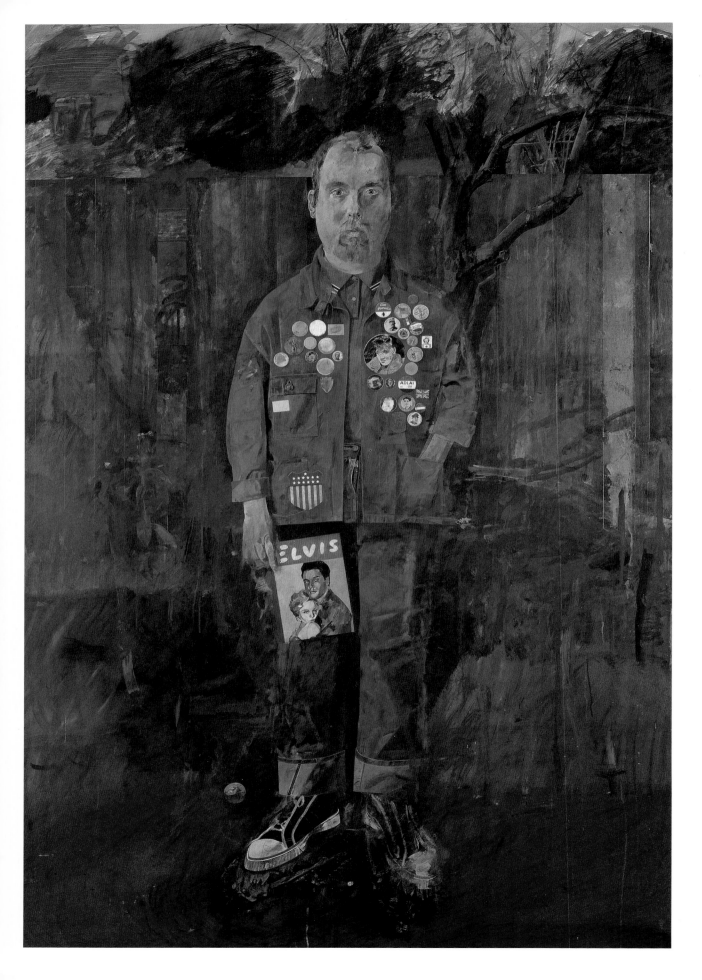

Blake's most famous self-portrait, the *Self-Portrait with Badges* of 1961 (fig.99), reiterates some of these themes, most notably the self-conscious, full frontal presentation of the body in order to align the self with celebrated others. The portrait marked a defining moment: in proclaiming his allegiances without embarrassment and supporting the concept of unconditional admiration and assimilation, Blake helped introduce the notion that artists could be fans and vice versa, thus affirming the fan as a creative, considered individual. It is therefore no surprise to learn that, in the years immediately following the production of Blake's portrait, both Pauline Boty and David Hockney made portraits on the theme of the sitter surrounded by his or her heroes. *Self-Portrait with Badges* is also significant in that it extends our understanding of the way in which fans develop their own image using, not portraiture, but performance. Within the privacy of his home, or rather, his back garden, Blake carefully developed his public image using costume and pose. Similarly, many fans turn to their wardrobes either to emulate the appearance of their heroes or to dress up in T-shirts and scarves imprinted with their features. In crossing the boundary between home and public life, fans in costume expose themselves to potential ridicule or derision. Many consider fans to lack a strong sense of self, hence the need to borrow the identity of another. Yet it is just as easy to read the fan as an individual secure enough to endure the consequences of a chameleonic persona swap, creative enough to pursue different narratives of the self, and brave enough not to follow the flock.

Just like artists, fans cross boundaries to achieve new ways of thinking about their relationship with the world, selecting their methods in accordance with the ideas they wish to express and the spaces in which they are able to work. Being a fan demands commitment: maintaining a certain lifestyle, going the whole distance. True fans will follow their heroes regardless of whether they are alive or dead, in or out of vogue, for capricious trends and fads have little to do with fandom. From his position as a fan and an artist, Blake finds great freedom to explore the interface between art and life while taking a similar view of his own fluctuating popularity. Art movements, like movie stars, may come and go, but this leopard rarely changes his spots: he knows that everything will come around again, given time, but even during those periods when his work seems to miss the moment, he feels content in being true to himself by continuing to develop his favourite subjects in innumerable ways. Peter Blake works as a fan.

SELF-PORTRAIT WITH BADGES
1961 [99]
Oil on hardboard
172.7 x 120.6 (68 x 47 ½)
Tate

253/12

POSTCARD 1962 [100]
Oil on hardboard
122 x 76.2 (48 x 30)
Private Collection

Notes

1 Christopher Martin (ed.), 'The Ruralists', *Art & Design,* no.23, 1991, p.36.

2 All quotes are from interviews with the author, February – March 2002, unless otherwise specified.

3 Margaret Lambert and Enid Marx, *English Popular and Traditional Art* (1946), London 1951, p.viii.

4 Suzi Gablik and John Russell, *Pop Art Redefined,* London 1969, p. 40.

5 Roger Coleman, 'A Romantic Naturist: Some notes on the paintings of Peter Blake', *Ark,* no.18, November 1956, pp. 60–1.

6 Ibid.

7 Robert Melville, 'The Durable Expendables of Peter Blake', *Motif,* no. 10, Winter 1962–3, pp. 15–29.

8 Ibid.

9 Robert Melville, 'Peter Blake and the Fairies', *New Statesman,* 5 Dec. 1969, p.835.

10 Peter Blake and Mervyn Levy, 'Peter Blake: Pop art for admass', *Studio International,* vol.166, no.847, Nov. 1963, p.184.

11 Peter Blake, 'Only Sixteen' (cartoon strip), *Ark,* no.25, 1960, p.29.

12 Gordon Burn, 'Blake's Progress', *The Sunday Times Magazine,* 30 Jan. 1983, p.28.

13 Simon Garfield, *The Wrestling,* London 1996, p.121.

14 Blake and Levy 1963, p. 189.

15 Peter Blake, 'Peter Blake in Hollywood', *The Sunday Times Magazine,* 15 Nov. 1964, p.27.

16 Blake and Levy 1963, p.189.

17 Peter Fuller, *Art Monthly,* March 1983, p.14.

18 Dawn Ades, Peter Blake and Natalie Rudd, *Peter Blake: About Collage,* exh. cat, Tate Liverpool, 2000, p.21.

19 Harriet Vyner, *Groovy Bob: The Life and Times of Robert Fraser,* London 1999, p.171.

20 Ibid., p.172.

21 Peter Blake, 'Blake Being Slightly Contrary', *Three Painters/Peter Blake, Jim Dine, Richard Hamilton,* Midlands Arts Centre, Birmingham, 1967.

22 David Bailey and Peter Evans, *Goodbye Baby and Amen: A Saraband for the Sixties,* London 1969, p.44.

23 William Feaver, 'London Letter', *Art International,* vol.17, no.3, March 1973, p.58.

24 Peter Blake and Colin Painter, 'Peter Blake in Conversation with Colin Painter', *Aspects,* no.22, Spring 1983, p.2.

25 Peter Blake, 'Contrariwise', *Aspects,* no.3, Summer 1978, p.2.

26 Vladimir Nabakov, *Lolita,* London 1959, p.44.

27 Peter Blake, letter to the editor, *The Guardian,* 20 July 1977, p.10.

28 William Shakespeare, *Hamlet,* Act IV, Scene 5. The art historical allusions are clearly visible in Blake's later reworking of *Ophelia* (see fig.78 on p.93), in which the background refers to Arthur Hughes' interpretation of the subject and the foreground to the version painted by John Everett Millais.

29 Hunter Davies, 'Portrait of the Artist (a work in progress)', *The Independent,* 19 May 1992, p.12.

30 Ades, Blake and Rudd 2000, pp.21–3.

31 Waldemar Januszczak, 'Cheeky Monkey', *The Sunday Times,* 13 October 1996, p.9.

32 Adrian Searle, 'The Aping of Art', *The Guardian,* 1 October 1996, p. 10.

33 Ades, Blake and Rudd 2000, p.15.

34 Maev Kennedy, 'Young Turks Shake Up Summer Exhibition', *The Guardian,* 10 Jan. 2001.

A Context For Peter Blake

1 Laurence Alloway, ICA catalogue introduction, 1960.

2 Blake and Levy 1963, p.189.

3 See Lewis (1991) and Hills (2002) for a valuable overview of research into fandom.

4 I would like to thank Vicky Charnock – Education Curator at Tate Liverpool and co-curator of the *Pin-Up* display – and artist Leo Fitzmaurice who worked closely with a number of fans, for their support of this text. I would also like to thank all of the fans for taking part in the project.

5 'Peter Blake discusses collecting with Andrew Lambirth' in *A Cabinet of Curiosities from the Collections of Peter Blake,* exh. cat., Morley Gallery, London 1999, p.17.

Biography

1932	Born 25 June, Dartford, Kent
1946–49	Gravesend Technical College and School of Art, Junior Art Department
1949–51	Gravesend School of Art
1950	Accepted by the Royal College of Art, London
1951–3	National Service in the RAF
1953–6	Royal College of Art, London
1956–7	Leverhulme Research Award to study popular art, travelled to Holland, Belgium, France, Italy and Spain
1960–2	Taught at St Martin's School of Art
1960–3	Taught at Harrow School of Art
1961–4	Taught at Walthamstow School of Art
1963	Married Jann Haworth
1964–76	Taught at the Royal College of Art, London
1968	Daughter, Juliette Liberty Blake, born
1969	Moved to Wellow, Avon
1974	Daughter, Daisy Blake, born Elected Associate Member of the Royal Academy of Arts, London
1975	Founding member of The Brotherhood of Ruralists with Jann Haworth, Ann and Graham Arnold, David Inshaw, and Annie and Graham Ovenden
1979	Separated from Jann Haworth Returned to London
1980	Met Chrissy Wilson
1981	Elected R.A. (Member of the Royal Academy of Arts, London)
1983	Awarded CBE
1987	Married Chrissy Wilson Daughter, Rose Blake, born Made a Royal Designer for Industry
1994–6	Third Associate Artist of the National Gallery, London
1998	Honorary Doctor, Royal College of Art, London
2002	Received Knighthood Professor of Drawing at the Royal Academy Schools Lives and works in London

Solo Exhibitions

1962 Portal Gallery, London

1965 Robert Fraser Gallery, London. Cat. notes by Robert Melville.

1969 *Peter Blake: French Postcards, Exhibition of Screenprints*, Leslie Waddington Prints, London

Peter Blake: Drawings, Watercolours and Art Work Originals 1968-9, Robert Fraser Gallery, London

City Art Gallery, Bristol. Cat. intro by Roger Coleman.

1970 Ashgate Gallery, Farnham

1972 *Peter Blake: Watercolours and Drawings*, Waddington Galleries, London

1973–4 Stedelijk Museum, Amsterdam; touring to Kunstverein Hamburg; Gemeentemuseum, Arnhem; Palais des Beaux-Arts, Brussels. Cat. texts by Rainer Crone and Uwe M. Schneede.

1974 *Peter Blake: Print Retrospective*, Natalie Stern Gallery, London

1977 *Peter Blake: Souvenirs and Samples*, Waddington and Tooth Galleries, London. Cat. intro by Peter Blake.

1978 *Peter Blake: 'Side Show' 1974-78*, Waddington Graphics, London

1979 *Peter Blake: Drawings and Prints*, Bohun Gallery, Henley-on-Thames

1980 Galleria Documenta, Turin

1983 Tate Gallery, London (retrospective exhibition); touring to Kestner Gesellschaft, Hannover. Cat. texts by Michael Compton, Nicholas Usherwood and Robert Melville.

1984 Galerie Claude Bernard, Paris. Cat. text by Peter Blake and Leslie Waddington.

1986–7 *Peter Blake: Commercial Art*, Watermans Art Centre, Brentford; touring to Turnpike Gallery, Leigh. Cat. text by Nigel Leighton.

1988 *Déjà Vu*, Nishimura Gallery, Tokyo. Cat.

1990 Waddington Galleries, London
Wetterling Gallery, Gothenburg

1992 Govinda Gallery, Washington D.C.

1993 The Tabernacle Cultural Centre, Machynlleth

1995 Galerie Claude Bernard, Paris. Cat. text by Marco Livingstone.

1996–97 *Now We Are 64*, National Gallery, London; touring to Whitworth Art Gallery, Manchester. Cat. texts by Marco Livingstone and Colin Wiggins.

1999 *A Cabinet of Curiosities from the Collections of Peter Blake*, Morley Gallery, London. Cat. text by Peter Blake and Andrew Lambirth.

2000 *Peter Blake: About Collage*, Tate Liverpool. Cat. texts by Dawn Ades, Lewis Biggs, Peter Blake and Natalie Rudd.

2001 *Alphabet*, York College, York (National Touring Exhibition organised by the Hayward Gallery), touring Britain until 2006

2002 *Over the Rainbow*, Harley Gallery, Welbeck

Sir Peter Blake/And Now We Are 70, Paul Morris Gallery, New York

Selected Group Exhibitions

1958 *Five Painters* (with John Barnicoat, Peter Corviello, William Green and Richard Smith), Institute of Contemporary Arts, London

The Guggenheim Painting Award 1958: British Section, Whitechapel Art Gallery, London

1960 *Theo Crosby: Sculpture, Peter Blake: Objects, John Latham: Libraries*, Institute of Contemporary Arts, London

Grass by Tony Gifford, Gold by Peter Blake, New Vision Centre, London

Peter Blake, Roddy Maude-Roxby, Ivor Abrahams, Portal Gallery, London

1961 *Peter Blake, Pauline Boty, Geoffrey Reeve, Christine Porter*, A.I.A. Gallery, London

John Moores Liverpool Exhibition, Walker Art Gallery, Liverpool

1962 *British Painting and Sculpture Today and Yesterday*, Arthur Tooth & Sons, London

New Realists, Sidney Janis Gallery, New York

1963 *Pop Art*, Midland Group, Nottingham

Troisième Biennale de Paris, Musée d'Art Moderne de la Ville de Paris, Paris

Drawings, Gouaches and Collages, Robert Fraser Gallery, London

1964 *Painting and Sculpture of a Decade: 54-64*, Tate Gallery, London

Summer Exhibition, Robert Fraser Gallery, London

Pittsburgh International, Carnegie Institute, Pittsburgh

I.C.A. Screenprint Project, Institute of Contemporary Arts, London

1965 *Peter Stuyvesant Foundation: a Collection in the Making*, Whitechapel Art Gallery, London

London: The New Scene, Walker Art Center, Minneapolis; touring to Washington; Seattle; Boston; Vancouver; Toronto; Ottawa

1966 *Blake, Boshier, Caulfield, Hamilton, Paolozzi*, Studio Marconi, Milan

1967 *Works from 1956 to 1967 by Clive Barker, Peter Blake, Richard Hamilton, Jann Haworth and Colin Self*, Robert Fraser Gallery, London

Jeunes Peintres Anglais, Palais des Beaux-Arts, Brussels

Englische Kunst, Galerie Bischofberger, Zurich

Three Painters: Peter Blake, Jim Dine, Richard Hamilton, Midlands Arts Centre, Birmingham; touring to Arts Council Gallery, Cambridge

1968 *Old Testament Drawings*, Oxford University Press, London

The Obsessive Image 1960–1968, Institute of Contemporary Arts, London

From Kitaj to Blake: non-abstract artists in Britain, Bear Lane Gallery, Oxford

1969 *Pop Art*, Hayward Gallery, London

1970 *British Painting and Sculpture 1960–1970*, National Gallery of Art, Washington

An Exhibition of Paintings, Drawings and Screenprints by Peter Blake and Graham Ovenden based on the theme of Lewis Carroll's 'Alice', Waddington Galleries, London

1971 *Critic's Choice*, selected by Robert Melville, Arthur Tooth & Sons, London

1973 *11 Englische Zeichner*, Staatliche Kunsthalle, Baden-Baden; touring to Kunsthalle Bremen, Bremen; I.C.C., Antwerp

1974 *Peter Blake* (with works by Jann Haworth), Festival Gallery, Bath

Peter Blake's Selection, Festival Gallery, Bath

British Painting '74, Hayward Gallery, London

1975 *European Painting in the Seventies: New Work by Sixteen Artists*, Los Angeles County Museum of Art, Los Angeles; touring to St. Louis Art Museum, St. Louis; Elvehjem Art Center, Madison

1976 *Pop Art in England*, Kunstverein, Hamburg; touring to Munich; York

Arte Inglese Oggi 1960–76, British Council exhibition, Palazzo Reale, Milan

Peter Blake, Richard Hamilton, David Hockney, R.B. Kitaj, Eduardo Paolozzi, Boymans-van Beuningen Museum, Rotterdam

Royal Academy Summer Exhibition, Royal Academy of Arts, London

1977 *Hayward Annual*, Hayward Gallery, London

The Brotherhood of Ruralists, Festival

Gallery, Bath; touring to Edinburgh; Doncaster; Southampton
British Painting 1952–1977, Royal Academy of Arts, London

1979 *The Brotherhood of Ruralists*, Charleston Manor, Seaford
The Brotherhood of Ruralists, Gainsborough's House, Sudbury
This Knot of Life, L.A. Louver Gallery, Los Angeles

1980 *Ophelia: Paintings and Drawings on the Theme of Ophelia by the Brotherhood of Ruralists*, City Museum and Art Gallery, Bristol

1981 *The Ruralists*, Arnolfini Gallery, Bristol; touring to Birmingham; Glasgow; London (Camden Arts Centre)
Six British Artists, Prints 1974–1981, Waddington Graphics, London

1984 *The Hard Won Image*, Tate Gallery, London

1985 *La Vie et l'Oeuvre de l'Ecrivain*, Galerie James Mayor, Paris

1986 *Forty Years of Modern Art*, Tate Gallery, London

1987 *British Art in the 20th Century: The Modern Movement*, Royal Academy of Arts, London

1988 *The New British Painting*, The Contemporary Arts Center, Cincinnati; touring to Chicago Public Library Cultural Center, Chicago; Haggerty Museum, Marquette University, Milwaukee; Southeastern Center for Contemporary Art, Winston-Salem; Grand Rapids Art Museum, Michigan

1991 *Art In Boxes*, England & Co, London
Pop Art, Royal Academy of Arts, London; touring to Museum Ludwig, Cologne; Centro de Arte Reina Sofia, Madrid

1992 *Ready, Steady, Go: Painting of the Sixties from the Arts Council Collection*, Royal Festival Hall, London; touring Britain
Pop Art, The Montreal Museum of Fine Art, Montreal

1993 *The Sixties Art Scene in London*, Barbican Art Gallery, London

1994 *Elvis + Marilyn: 2 x Immortal*, The Institute of Contemporary Art, Boston; touring the United States

1995 *Paintings from the 60s and 70s: Peter Blake, Patrick Caulfield and Howard Hodgkin*, Waddington Galleries, London

1999 *Collage – The Pasted-Paper Revolution*, Crane Kalman Gallery, London

2001 *Pop Art U.S./U.K. Connections, 1956–1966* The Menil Collection, Houston
Summer Exhibition, Royal Academy of Arts, London
Royal Academy Summer Exhibition, Royal Academy of Arts, London
Les Années Pop, Centre Pompidou, Paris

2002 *Transition: The London Art Scene in the Fifties*, Barbican Art Galleries, London
Pin–Up: Glamour and Celebrity since the Sixties, Tate Liverpool, Liverpool

2002–3 *Blast to Freeze: British Art in the 20th Century*, Kunstmuseum Wolfsburg, Germany

Selected Books and Articles

1956 Coleman, Roger, 'A Romantic Naturalist: Some Notes on the Paintings of Peter Blake', *Ark*, 18 November, pp.60–1

1958 Melville, Robert, *Architectural Review* (review), April, vol.123, no.735, pp.278–9
Coleman, Roger, 'The Art of Counterfeit', *The Painter and Sculptor*, vol.1, no.1, pp.21–3

1962 Russell, John, 'Pioneer of Pop Art (People of the 60s)', *The Sunday Times Colour Section*, 4 February, pp.16–17
Melville, Robert, 'The Durable Expendables of Peter Blake', *Motif*, no.10, Winter, pp.15–29

1963 Blake, Peter and Levy, Mervyn, 'Peter Blake: Pop art for admass', *Studio International*, November, vol.166, no.847, November, pp.184–9

1964 Blake, Peter, 'Peter Blake in Hollywood', *The Sunday Times Magazine*, 15 November, pp.27–31

1966 Alloway, Lawrence, 'The Development of British Pop' in Lippard, Lucy (ed.), *Pop Art*, London, pp.27–67

1970 Coleman, Roger, 'Peter Blake's Nostalgia', *Art and Artists*, January, vol.4, no.10, pp.30–2

1976 Moynahan, Bryan, 'Brotherhood of Ruralists', *The Sunday Times Magazine*, 3 October, pp.78–84

1978 Blake, Peter, 'Contrariwise', *Aspects*, no.3, Summer, pp.1–2
Blake, Peter and McGough, Roger, *Summer with Monika*, London
Usherwood, Nicholas, *The Brotherhood of Ruralists*, London

1982 Hackney, Stephen, 'Peter Blake: The Masked Zebra Kid', *Completing the Picture: Materials and Techniques of Twenty-Six Paintings in the Tate Gallery*, London, pp.104–7

1983 'Peter Blake in Conversation with Colin Painter', *Aspects*, no. 22, Spring, pp.1–5
Burn, Gordon, 'Blake's Progress', *The Sunday Times Magazine*, 30 January, pp.23–8
Overy, Paul, 'Peter Blake: Un Certain Art Anglais', *Art Monthly*, March, pp.12–13
Amaya, Mario, 'Peter Blake The Ultimate Fan Male', *Studio International*, vol.196, no. 847, April/May, pp.31–3

1985 Blake, Peter, 'Peter the Painter' (Blake in conversation with David Litchfield and Celia Lyttelton), *Ritz*, March, pp.57–9

1986 Vaizey, Marina, *Peter Blake, The Royal Academy Painters and Sculptors*, London
Vaizey, Marina, *A Knowing Innocence: Peter Blake in Conversation with Marina Vaizey* [audio tape and slides], Lecon Arts

1991 Lewis, L.A. (ed.), *The Adoring Audience: Fan Culture and Popular Media*, London
Martin, Christopher (ed.), 'The Ruralists', *Art and Design*, no. 23

1992 Davies, Hunter: 'Portrait of the Artist (A Work In Progress)', *The Independent*, 19 May, p.12
Compton, Michael, 'Pop Art in Britain', *Art and Design*, no.24

1996 Garfield, Simon, *The Wrestling*, London
Greig, Geordie, 'Blake's Progress', *Modern Painters*, Autumn, pp.72–4

2000 Poynor, Rick, 'The Celebrated Mr B', *Eye: The International Review of Graphic Design*, vol. 9, no. 35, Spring, pp.26–35
Johnson, Holly, 'Meeting the Magician', *Modern Painters*, Summer, pp.90–3

2002 Hills, Matt, *Fan Cultures*, London
Painter, Colin (ed.), *Contemporary Art and the Home*, Oxford

Copyright credits

Photographic credits

Index